*Sudden Thought,
Even Saint have Confessions*

Learning lessons after writing thoughts of a Saint and Sinner, all the relationships, all the emotions, "Who's Heather" being the opening poem, also getting the most attention, people wanting to know who's heather ? Heather start out as one person that turns into many women, many unnamed women.

My intentions was never to blast out anyone writing these poems. I expressed what was going on at the time, during my life,

That was the reasoning for not placing any poems in a timeline, in the first book

The Thoughts of a Saint and Sinner, raised too many questions,
in my personal life. "Sudden Thoughts" shall to be the answers for some of the most heartfelt poems, I've ever written. This time I'm not holding back,
Then like a sudden thoughts, I find myself writing this book...

by John Frost
Copyright exclusive to Poetic Knights Inc.
San Bernardino California
ISBN-13:
978-1542928236

ISBN-10:
1542928230

Their Looking From a Distance

Their looking from a distance speaking about me,
Yet I'm living my dreams,
I took all the skills I've ever gotten from the streets
Placed it all in my passion, into this poetry,
Educated thug, that's what they call me,
I pay them no mind, I stay on my grind,
And now I'm living my dreams,
They looking and judging, talking and suggesting
Hating on my positivity,
2Pac said only God could judge me,
Before that there was one that died on the cross for me,
So I don't trip on what the other side has to say about me,
Cuzz now I'm living my dreams
It took all the ambition I had to succeed at this life
Determination and driven soul,
And to keep it real, I mean all the way real
I didn't do this alone, I have a few friends to support my dreams.
End of reality spoke on how life once ended for me, Prison sent, only to redirect my mind set

God's plan changed the man, now; more than ever I understand, what it means to be a man.

Searching trying to find oneself.

I've been everywhere, religion, in the streets, in different women's arms. It wasn't till I found myself writing and reading my own words, that I would find out who I really was, and whom I was about to become. The journey came like a sudden thought.

Father, to my girls. A deadbeat dad to my children this was not in my life, there are somethings you just can't change or explain. These become the hardest situations to live with.

The world on my back.

I still have to go to work
I still have to pay bills
I still have to be a Father,
I still have to find a way to be happy,
I still want to be loved,
I still want this dream of being a successful writer/poet.
Still the world feels like it's on my back.
What do you do when you feel like the world on your back, do you change up to give up, here's what happens in my life, like a sudden thought.

I became a life poet

I'm writing for the sake of love,
family love, relationship love......
Here some great love

Daddy and Carrie

Daddy wake up it's time to go to work,
Daddy milk, Daddy milk Daddy Milk,
Daddy the monkey, Daddy the monkey,
She's runs in the room, turn the TV on,
I set the movies she wants on,
She's watches for about ten minutes,
Daddy, Daddy Daddy,
Yes,
Is Najay and Destiny coming over?
Yes for the summer.
Daddy love you,
Carrie, love you,
She goes back and watches her movie, for about ten more minutes. Then it's back to the questions till dinner time, and one more question right before bedtime,
Love is what love does, her love has endless questions, and I so enjoy them

 Then the next sudden thoughts of
 life hits,

Friends losing friends, family losing family,

So much mourning, tears falling, so much pain in the world today,
Cherish each moment you have with love ones,
Never forget, hold each memory,
Friend of a friend, never give in,
Live life, try our best to do it right,
Love and forgive, treasure the happiness in each moment,
Love out loud, stand on a mountain, and stand proud
For the only thing that lasted forever,
Even when it's as light as a feather, is love that never feathers,

Suddenly the thoughts got personal

Still visiting you're in box,
Even though your gone,
your page is deleted,
I'm still able to visit your in box,
conversations no one knew we had,
a friendship no one knew we had,
I know I'll never get an in box from you again,
I know there's no one that going to tell me
Johnny they hating, keep doing your writing and posting
I'm reading,,,,
Never knew I would lose a friend from Facebook,
Never knew I would think about you from time to time,
Never knew when I look On my IG account you would be there,
Never knew I would still have tears in my eyes cuzz I never got to say goodbye,
Still visiting your in box,
To all that's chosen to live on, yet still hold on.

Losing friends while writing the thoughts of saint and sinner, friends from a far and close wanted me to write openly, I couldn't do it,. Wrote the poem and never posted.

This was inspired by a Friend that we all lost in a Facebook group, she was a really good person, I watched her find love and enjoy life...

Tam Tam you'll be missed

Sudden Thoughts emphasis

Too many of my friends have lost love ones, and silently tears falls reading each ones post in this social media world. There's only so much any of us can do, pray send condolences, And sometimes, that doesn't seem enough.
Suddenly life finds it way, and we move on.
You take a man like me, a person that expresses his emotion freely, then add into that, building friendship with people across the world, in chatrooms with people I tend to talk with about personal matters, things that really matters in my real life. Cuss it's just me in the room with my computer, it's an illusion. Only to go bed then wake up every morning start chatting to the same person, I'm building bonds with that person. Lost is lost when it comes to friendship. So it hurt to find out I lost a friend to death… even if I did just meet that person on social media….
They say there's a thin line between love and hate, there's an even thinner line between reality and Social media…. the little things that will have me in my thoughts, The little things that inspire my passion, The little things that create so much emotions,
And then like a sudden thought,

Sudden thoughts of Heather,

My heart changed
My love changed
My life changed!
Could you've been the reason?
Stepping away from you,
Not speaking to you,
Not wanting you,
Yeah you're the reasons,
And I want to thank you for leaving
Cuzz now you've allow the right person to step into my life.
I wish you all the best,
I wish that you find that man that makes you happy,
I never could,
I became the trash that you wanted outta your life,
But you never wanted to throw me away.
Not till this moment,
I now realizes, looking through my own eyes
That I'm worth so much more than the money I spent on you!
That I never had to settle, that I could get a woman on my level...

So yeah
My heart changed
My love changed
My life changed!
Cuzz Now I love me better!

The truth of the matter Heather and I were great in bed, bad as friends and good as lovers, as long as she needed me, I needed her, when she no longer need me. I no longer wanted her!

The mood would change one more time, and the thoughts would become intense once again, funny how death inspires creative thoughts,

An in-box to heaven,

I got questions I want to ask,
Like why it had to be her, why couldn't we finish out this life together?
They say the good die young, and only the strong survive,
I say the beautiful taken too soon,
I'm have to be strong to go on without you in my life,
These words cries, as long as I have a breath in my body,
We're both alive, I'm going carry your memories with me for the rest of my life,
I know when it comes to the end of my time,
I may not make to where you are,
But the love I have for you, surpasses distance and time,
Different paths in life, and maybe different paths in the afterlife,

So while you're in heaven, just do me a favor,

Tell my grandmother I love her,

Get to know her, she'll show you around,

I don't want to take up to much of your time,

I just wanted to chat to you, while I had the time...

An in-box to heaven,

Sudden Thoughts of Heather again and again,

Chasing Love, or love chasing,
You've been looking for clarity after every relationship, I've been looking for serenity in different women, We've been friends for going on three years now, We've both been looking in this infinite world of people, Both keep coming up with nothing.
Seem like we're not learning our lessons,
I know it was a blessing meeting you, But it seem we've been passing up the opportunity placed in front us, when you and I would be a great unit of love and trust. Inspired by passions and sins, we're still a good deed, together.
 They say, real realize real lies, I say too many despise real tries, and for once in my life,
I'm taking a real try at being the man in your life....
Let the world speak trends, these people speaking never get it in, With real truth I'ma speak my mind and like in the movie brown sugar,
I no longer want to be your friend
Will you be my girlfriend?
And since you can't circle yes or no, just push the like,

And once you do, like fireworks, we'll take flight

*Direction? To the heavens of love
No more exploring the world without a destination
I'll be the man giving you the love and attention.*

So Ma you might want to give us a try?

Of what I Knew of Her

What happen in this next little story kind of shocking,
Like sudden thoughts altogether,

Of what I knew of her, she was a sane as could be, beautiful, charming, sexy queen. With a look so interesting, she was a walking dream, so enticing.....
Her love for her man, deep, but he wasn't giving her everything she needs, in fact, he never trusted her with anything.
I watched from a distance, never offering my assistance, knowing all she needed, was for her man to understand, she was all he needed.
This Cat stayed in the streets, with different women, as I remembered... With a committed woman at home, Outta respect for him she was on lock down,
Then the call:
Johnny I need you just listen, please stay on the phone,
(What I thought I was about to hear, wasn't what I thought I would hear.)
(Shower cutting off :)
Heather: Are you there?

Me: Yeah I'm here,
Ok:
(She started telling me what she was doing laying the phone down with the speaker on ok!)
Heather: Ok, What are you doing tonight?
Me: Nothing just got off work, about to cook dinner for myself, call the kids then off to bed...
Heather: Johnny that's not what you're going to do and you know it, you are about to get on Facebook, chat with some random woman, and then starting writing poems...
Me: LOL! Girl you know me well,
Heather: All of Facebook knows you well,
Me: what are you doing tonight?
Heather: I'm about to give you something to write about!
Me: yeah really and how do you plan on doing that?
Her: I have a nasty story to tell you!
Me: what about your man??? Lol, tmi
Heather: No not about my man!
Me: Lol, Ok then... Do tell!
Heather: I plan on it!
Heather: I call myself in love with this man, but tonight I'm here by myself, touching myself, night after night, I'm looking for my own passions,

giving myself own affections, I find myself reaching, and touching parts of my body, (moaning), lusting needing attention...
My curvaceous shape going insane from the lack of his touch, Johnny I want him so much, I need him to make me feel like a woman again... I know what he's doing, what he's done, I still love him. I need him on top of my wet body; I want his tongue tasting my insides, while his hands caress my breast. (Moaning), oh Johnny I still love him. I want to taste his man hood, I want to put him in my mouth, and I want to 69, all night, Johnny!
Me: Heather, Lol, that all sound interesting your desires for him, why are you telling me?
Heather: Johnny, really, it's not him I desire!
Me: Ok, so who is it?
Heather: I've never cheated, but I need pleasing, will you cum with me? You claim you're the last of the best, and the best of what's left, I want to put you to that test!
Me: Heather, as long as this stay's between you and me, and away from your man, and my girl.
Heather: It never happened....
Me: I'm on my way, tonight I excite your body right!

At some point you would think I would have a handle on situations like this, yet the dog in me never seems to learn, I went over to this woman house, made love to Heather, as if she were my woman, in my heart I was saying this is so wrong, in my mind I didn't care. Making love to a married woman was a thrill in itself. Even bigger thrill keeping the secret from my own woman. I was in love with my woman, I just wanted a little excitement!

And like sudden thoughts everything changes

Random flirting, ego out of control, dropping lines, just to get a hello!

Dig the flow doe!

Yeah Miss Lady,
Hello, Miss Lady, How you doing,
Looks Like you having a nice day,
I see it in the looks of your eyes,
The depth of your smile,
Miss Lady Want to get to know you,
Look here my name Johnny Frost,
Known to know how to treat a lady,
And don't worry, after a while I'll start to call you my Baby,
Still treating you like a lady,
From this convo,
I know you're oh so enjoying,
I'm oh so enjoying you're laugh
I'll try my best not to make you mad,
And do everything I can to keep you from being sad,
Want to be the friend you never had,
Want to get to know ya,
Miss Lady My Name Johnny,
Miss Lady I want you to feel this energy,
Let me take you to romance,
Let me make your body dance,
Let me show you all that I can,
I love that grin, smile for me again,

*Miss Lady, you really should get to know Johnny,
I got the confidence of 20 men,
And the kind of passions that can last for eternity
You know you want to get to know this,
You got every right get to know this,
This our first convo,
So I'm just going to blow you this kiss....
I'll be the best man I could ever be,
Your loyalty, inspire me,
Believe in me never give up on me,
Baby I need you to really get to know me,
So that you trust in me,
You'll see we were destine to be,*

It always seems I'm writing for someone, sometimes what inspires my write could be a song that I wanted to rewrite into my own words, the beat had me going.

Once I post it on line people tend to take it for whatever they want, Sometimes poems I write may mean nothing to me, but everything for someone else. I just take as that's the reason I write it in the first place. Sudden thoughts many people have them, the only difference is that I tend to write mine down more than others, writing for myself is a healing tool.

If I inspire others to do the same, that's a side effect, I truly believe that writing is contagious... I've watched others read someone's work and a day or two later they'll write some the most inspiring poetry... Like Sudden thoughts,

If I told you I loved you!

If I told you I loved you!
Would it run you off?
If I told you that I couldn't see any other woman's beauty passed yours,
Would you believe me?
If I told you I believe that we were meant to be!
Would you trust me?
If I told you, that I would do anything to make you happy!
Would I be crossing a line?
If I told you, all I want to do is come home to you,
That I want to share my world with you and only you!
Would I be saying too much?
If I told you,
That I Wanted to marry you!
What would you say?

I keep going through these relationships, still wanting to get married. Every word in this poem is real,

Maybe one day I'll find that one that will say yes, Lady Love please say yes,

With all that's going on in the world today, really, and artist like me already got a million things on my mind, this can't be what I wrote,

Well that's what I tell myself

Been feeling pain

Been feeling pain still smiling, what's really on my mind,
One day I'll spit like I write, it ain't going to be to night,
So much pain, dealing with a headache, this isn't my write,
Would the world miss me if I were to just fade away?
Lost in these words tonight, I hear the music, still I isn't got the ambition to fight,
Do you trust me, I mean do you trust my actions, or am I just acting,
There's a hidden message, you don't see it, maybe not,
There are dreams that ghost's dream, dead bodies coming back to life,
Forgotten about demons coming home to rest,
While confessions being misdirected, infectious with the misconceptions
That Nigga's going to be alright, praying to a God that doesn't feel the same,
Still and yet there's is perfection in the death of the night,

*I don't want to believe this is my write tonight, yet this is my write tonight,
The ravens sits at the cross-roads,
Just waiting to take another nigga to his final home,
Thanks again to the NYPD, LAPD, AND WHATEVER other PD
Dreaming the dreams that ghosts dream,
Rest in peace we all want to believe, but we all know, Nigga's like me,
Won't find eternal peace, death and life, life and death,
Don't waste your time praying for me, I dream the dreams that ghost dream,
So much pain, I can't believe I'm in so much pain,
This can't be what I wrote!!!!!!!!!!!!!!!! What's wrong with me???*

Yeah even I get on one, I wrote it,
Can't always be emotional about the women in my life,

Sometimes we all have to take a minute to look at the lager of life

Words left

I'm going to let life play out the way it's going,
If I write, I'll die a legend,
Words left in the minds eyes of millions
Remembered for how many heart touch,
Yet untold, so many emotions uncontrolled,
Late night dreams about desiring the right Queen,
Casting spells, for roll playing just don't tell,
Loved for the test of life,
May I ever find the woman that'll be my wife?
I've come to understand that's alright,
Still loved and that's cool,
Cuzz I love my life without a wife,
Cuzz finding love and loyalty ain't reality,
There should be a questions here,
I mean really?
So I'll write to the fantasies that'll never turn to realities,
the reality is I'm already married,
Married to poetry, and that's fine with me,
I'll die a legend,

Sudden thought of giving up on relationship, yeah it happens, something or someone always comes alone to change my mind.

True story, It's a Neo-Soul Night

And as I stepped through the door I seen an amazing sight,
I don't know if was the dim lights,
Miss Lady the way you fit that dress,
I was like, yeah Ma right,
Had my mind's desire on a natural high,
I see nothing or no one for the rest of the night,
I heard nothing, could even get my words right for the night,
I wanted to change my spoken words,
I wanted to make love to your mind,
I wanted to caress your soul with my words,
Damn Damn damn am I really saying this out loud on Facebook,
I couldn't even believe she recognize who I was coming through the door,
Hey Johnny are you preforming?
Aww I hadn't planned on it,
Come on, I'm signing you up,
Lol OK,
I stepped over to the bar, the bartender sexy as all out doors, but had nothing on Her, I make my order, Bacardi and orange juice, As she make my order, My eyes started craving for the eye candy it just seen,

My mind starts racing, catching this sexy amazing woman dancing, moving
Undercover thoughts

Damn Want to know if you move so good under the cover,,
Thickiemacutie with a nice booty,
Damn, can I left you, only to taste you, only to make you moan?
The neo-soul nights, poetically flirtatious writes
Damn I love these Poetic soulful lustful nights,

Real Talk,

Let's get on some real Talk, shit real quick
I want you black woman,
Let's start a family just you and I
If we do it together Ladies I know we can do better,
However many trust issues we got let's start to stop placing blame,
Ladies let's exchanges last name,
No longer looking at life as a game,
Let's make a change,
Let's get on some real talk shit, real quick,
Let's take vacations together to wherever
Black woman, I'm speaking to you,
I'm not seeking the teaching of the world to be true,
I'm seeking a truth between you and me,
Between you and I the sky the limit,
We don't a drug to catch this natural high,
Let's get on some real Talk, shit real quick
I'm going tell you how we start,
Ladies let me give you a call
Give me the conversation that intrigues my mind.
Allow me to say things that will put a smile on your face,

Laughter in your heart,
Let's enjoy each other company,
Yeah that's a great start on once again finding your heart,
Let's get on some real talk,

I had gotten to the point where all I wanted to do is see black people make it in a relationship my poetry started to reflect that, When your 38 years of age and you still haven't seen a successful relationship, or haven't been in one kinda sad! And everything like a sudden thought!

Sometimes it's all about the flow,

And then again things can get a little dark,
It's on the dark-side of life
Thing ain't right,
I've spoken on love and life,
Right now I ain't loving and life,
Things just seem like nothing going to be alright,
Sometime it's feel like I ain't going make it through the night,
So I stay awake to keep from the fright
Of not making it in life,
Haven't slept in weeks,
Man I'm weak in need and hoping
It's on the dark-side of life.
Will I really be able to take care of my seeds?
It's on the dark-side of life...
Heart and soul bleeds,
I really need something to happen for me,
I'm lonely,
Learned to many lessons of what ain't right,
The fighting, arguing, the screaming
Has gotten me nowhere in life,
Options on pain lost in the games

Has nigga going insane

*That just part of the crazy man talk
Life's lost game...
Who knew this would be the next thing I write?
It's on the dark-side of life...*

Love you till the ends of time,

You can trust in me, I will love you till the ends of time,
If you need commitment I'm willing to give it,
If you need me to hold you, day and night,
Baby I'll be right here for you,
I'm done playing games, I'm done, and I wanna change your last name,
I wanna provide and protect for you,
Allow my love through, let's become the almighty living truth,
Let's walk together for eternity, can't you see the turn me,
I love you, I wanna do for you, let's say them I do's
It's up to you, whatever you wanna do,
I'll do whatever I gotta do to get you to see my truth,
I'll do whatever to get you see this is what I want to do
Love me now, never leave me alone, make my heart your home,
Look into my eyes, enter my soul, and see your reflection,
Understand with me is where you belong,
My love for you is a never ending love song,

Love me now, never leave me alone, and make my heart your home!
And I'll love you till the end of time

Sudden Thoughts more about Johnny Frost

When I started writing as a child I was doing it for fun, not for show, but I loved the thought of making a record about life, just writing every little moment, as a child I told myself one day I'll write something that'll shock the world, big dreams like any kid, as I got older, the need to write kind of faded away, you know what happened.
 Girls, and like any teenage boy. my writing started coming out in things I would say to girls, They were like are you a poet? My reply, baby I'm whatever you want me to be for the night, most times the girls would just laugh and smile,
As time goes on so does life move on, sudden thoughts
Children, job, street hustling, cheating you know, life.
After a while poetry started to come back in the strangest way,
 I would write on everything, I do mean everything, just to get my thoughts out. My Children's mother would get upset to come home seeing I redecorated the house with poetry on the closet doors, and walls. She would say things like are you a mad man? So for my 26 birthday she got

me a note pad, write on this she said,
she never thought it was funny, I still think it's hilarious

As time goes on so does life move on,
You know I hide nothing from anyone, yes I've been to prison,
I'll be the first to say I'm not perfect to anyone standard, not even my own, I make mistakes. But I've always taken it as it's what you learn from the mistakes. That's what makes the person, not his or her the mistake. I could be wrong.

 Prison time, especially Federal time will give you a lot to think about when it comes to mistakes, I used that time as wisely as I could,

 I wrote and read everything I could, my routine, 200 push-up, an hour of reading religious, any religion. Then to the chow hall for work, taking with me, my pen and pad. When chow was done, I clean up with the rest of the fella, then CO would let everyone go back to the yard, I would stay in the chow hall, rather than hanging out, I needed write, and do more push-up, next hour movement I would go to the weight yard, lift with the Watts set, cuzz No one from San Bernardino was on fed time, no one but Johnny Frost at Terminal Island. The Blood card wanted to me to be a part of their workout set, wasn't happening they want more, what they really wanted was for me to work the chow hall for them,, I didn't have

enough time for that kinda bullshit, plus I wasn't going to be anyone mark.
Og Red was what they called him, Dude was cool but was always trying to figure out my story, you not like other nigga in here, I don't think you should be here, who you doing time for? This question was asked every other day,,, Red man I'm doing my time that who I'm doing time for, One of the older Crips came in the room one day, while Red was into his questioning,
Leave the young homie alone, you see he don't fuck with anyone, let him be, Red...
It really didn't bother me that Red had questions, I was green in this place I need to know the ins and outs, Red had been down 14 years already and was looking at another seven, while I at this time was looking at only three years. Why not be cool with dude,
Og Crip on the other hand was real cool, he also like to school the youngsters, first thing he said to me, you ain't gotta worry about getting raped...
Strange look came over my face like nigga I wasn't worried about that anyway,
I soon learned what it meant to be a real man and keeping your word...

Gangsters Keeping their word

One of the OG Crip from some hood SCG somethings, asked me for a favor that later he paid back in full, but it wasn't till I got to Sheridan Oregon that I would receive it,
OG; Frost Cuzz,
Frost: What crackin Fam?
OG: I need you to write a letter for me, not just any kind of letter cuzz, a poem can you do this for me, I'll pay you two books,
(One books of stamps street value $8.45 prison value $4.35)
Frost: OG. What I look like charging you for a damn letter, I got you, who is it for?
OG: Look here kido, I know you knew to this whole prison system, you gotta use all the skills you have to earn money, and writing letters is a skill a lot of cats in here don't have, that's your ticket around here. Everyone's seeing the things you do, you don't pay too much attention to what goes on around you and you really should, like Crip walking on the track with your headphones on, you need to take one earphone outta so you can hear if something going down,
Frost: damn, ok, I got you,

OG: the letter for my girl, I fucked up, I wrote her a fucked up letter,
and I wonder if you got something that'll make it right,
Frost: I'll be honest with you OG, I only write from experience of what I know about the woman,
OG: then I'll tell you a little about her, you think can take it from there?
Frost: I'll try, never done this before, I'll give it a shot.
OG: Man that's all I ask,
After listening to the OG talk about his woman, I had a few ideas,
I knew what she like to do, what her favorite colors were, and the time that the two spent together, I went back to the dorm, did my last set of push-ups, and started on the poem, Forever talking to you became the poem, (which is now in my book Poetic Knight's The Thoughts Of A Saint and Sinner)
The next morning I seen OG in the chow hall I handed him his copy of the letter, he read it, and was amazed, I told him to rewrite the letter in his own hand writing, he pulls out the two books of stamps, I told him no thanks the info he gave me the day before was good enough it might have

saved me from getting into it with other inmates, he agreed...
About a week went by, I seen OG walking with a big ass smile on his face,
Frost: I see you happy you must be going home soon,
OG: Naw Cuzz I got eight more months, but I got a visit today from my girl, it's cuzz the letter you wrote, I really owe you man,
Frost: Naw Cuzz we good, and I'm happy for you,
OG: Cuzz you don't know when the last time I seen her, it's been nine months,
Frost: aww she getting ready for you to come home it had nothing to do with some poem I wrote! I started laughing
OG: well whatever the reason I owe you, I'll pay you back, that's my word,
Frost: I'll be here for another three years, we both laughed and went to the chow hall...

As time goes on so does life move on,
And before I got see OG go home, they transferred me to Sheridan Oregon Camp,,, the day before the transfer it seemed everyone on the yard knew I was leaving, there was no room in the RDAProgram at Terminal Island.

My points dropped during the short time I was there, My name came out on the call out, I had to go! That also meant I wasn't going to get anymore visits from my Mother/Auntie, my little girl wasn't going to be able to see me as well.
I was losing the only people that seem to care anything about me! When I got to my holding cell I broke down and cried. I was about to do the rest of this time alone, and I knew it.
When I got to Sheridan, I was broke, no stamps, no money on the books, no one's numbers, no nothing. I was fucked, and to make matter worst, there were only 32 blacks on a yard of 500 men.

The Cali card was weak, no job positioning, no clothing hook-ups.
I was truly in the most beautiful hell on earth, Terminal Island is like the streets,
Sheridan was like living in a white old folks home. So I did what I do best, got to myself, started reading and writing,
Programming, Spanish classes, French Classes, Movies classes, any classes.

Then one day everyone was going to commissary, everyone but me, shit I didn't have any money on the books, Mommy was busy and my daughter's

mother had moved on. I'd worked my way into the chow hall again so I was eating well.

I went to make a phone call to my older girls, as I was making the call, the balance came up, read $250.00 you have on this account!
What the hell? Did I punch in the right pen?
So I hung up, and did it again, same thing happened, I add 50 to the phone, then called my daughter's mother, she picks up, did you send me some money?
No, we talked for the 15 mins, then I had to wait an hour before calling someone else. I needed to know who sent me that money, off to the computers room I go. I check the name of who sent the money, it was a woman, but I didn't know the name.
I wasn't reporting this, I needed the money, and what kind of fool tells on this kind of luck, I took it as a blessing,
Days go by, then mail call, JOHN FROST!!!!!!
Yes it's my little girl's mother, I get the letter, but it's not from who I thought it was from. I go to check the computer room the name matched the person who sent the money. I finally opened the

letter up it has pictures of the OG and his lady. I knew where the money came from,
I wrote a few more times and OG wrote back, I knew I had a friend for life.

As time goes on so does life move on,

Getting out, dealing with new sudden thoughts

Nothing in Common What if

We had nothing in common, not a damn thing.
So when we fell apart, it really didn't matter,
No morning of a relationship,
No trying to get back together,
Cuzz the truth of the matter we knew better....
The beautiful of a sad situation now holds us together forever!
What if the part missing in your life had to do with missing your child?
What if someone took your child away?
What if the mistakes you've made could never be forgiven,
What if the mother of your child just took her away?
What if someone brain wash your child to believe you were the worst person on earth,
What if that person the mother of your child,

I'm always dealing with Baby mama drama, with one of my children mother I don't play into it anymore, Johnny come get your daughter, she's bad, she's breaking shit in my house, I just listen on the phone. I don't even say I told you so anymore.. it is what it is

Then Like a sudden thought I'm off to something or someone else,

Live life, like an addiction,

Without the inflection,
A reflection of great beauty in honor,
Know your value, shine within that light,
Know this as if it's a truth,
Drifting,
I Wonder how my stupid mistakes.
Will determine my children faith,
The sin of father,
I wonder why the fed want to hold on to my soul,
I wonder why my ego won't let the past go,
I wonder what it's like to live life,
Cuzz I don't live anymore,
Everything all sore,
Drifting away in my thoughts today,
It's like I been hurting, My blood been feeding me,
No one needs to do this much thinking,
With drinking,
, maybe my desire wanting to much,
Drifting maybe lusting got be my biggest sins,
But my pride been on a rise,
Cuzz I don't ask for help from anybody,
Gluttony got to be my spiritual felony,

The game of life:

It's deeper than most will ever know,
It's a drive,
It's a determination,
It's a belief...
The game of life:
The design is his,
The way we play the game,
Is our choice only,
Cuzz he allowed it to be that way,
The gifts are called blessing...
What we chose to do with these gifts will determine what our outcomes will be,
Listen to nothing I say, I'm insane man going crazy

Sometimes I'm writing to motive myself, making myself believe the words I write, but there are times that I'm writing for someone on social media, it's an in-box, someone wants to vent, or needs advice, Sometimes I wonder why they come to me, while other time I enjoy the company.. All and all it moves like a Sudden thought here in the moment gone in the next.

Threats of taking a child

Everything I say came to light,
You stay on page reading my emotions,
Yet you've moved on with your life,
You claim you want me to bond with our child,
Still in yet, you put terms and conditions,
She can't be around the new girlfriend,
She can't stay with her own father overnight,
It's these games, these game a baby's mama plays
Not hurting the child now, still in time,
I've told you time and time again,
I can't play these kind of games in life,
You want me to take days off of my job to spend time,
I got to pay my own bills, I got to other children,
I can't play these kind of games with you,
Then friends, family want to know?
Why doesn't this sorry ass nigga, don't come see his own child,
Its blame put all on me,
Then the threats of you saying,
What going to happen when another nigga's rising your child,
I've said it once I'll say it again,

Babies' mama number one: has a husband, they've been rising our children,
Babies' mama number two; been married for over three years now,
The threats of you taken our child away to another state,
Babies mama number three has done that six times now,
There nothing you can threaten me with, once again,
Been trying to work with you,
I've told you time and time again,
I won't work with terms and conditions, Now!!!!!!
Now the truth finally about to come out,
I was your secret lover, which got you pregnant, were we ever friends?
Johnny the side dick, Johnny the side kick, Johnny just some good dick on call...
NOT Till the moment you got pregnant,
YOU WANTED A RELATIONSHIP!!!!!!!!!!!!
I'm tired, and tried, put out to the side,
I moved on with my life, then one day you told me the greatest lie,
I love you, six months into your pregnancy, wondering why?
At that time, I was in a relationship,

And even doe that don't workout,
I still wanted to be there by your side when our child came into the day light,
You pushed me away, I kept begging you, and please let me stay,
Finally, I took the hint, you won't let be the MAN in our friendship!
Our child has your last name,
Now all I'm asking, let me spend time with our child!
Without you around,
DAMNIT YOU GOT A MAN NOW!
Please just let me spend time with our child,
I won't hurt her, I'll take care of her, I do love her.....
Don't send me another pic of our child unless I can spend time with our child!
I don't want to play these babies mama's games with you!
I won't ask again! I already have one pill to swallow, with not ever seeing Kay again,
Last prayer Lord, then I got to forgive and let go, I can't keep this on my soul...

Sudden thoughts don't seem so sudden now!

I-sit-at-night- then-dream-at-night- Part 2

Don't sleep-at-night
Cuzz-I-write, and even doe,
I'm about to post this poetry
Hoping someone read what I write,
Not necessarily for attention
I need to know that someone can relate to my write
Write-dreams-from-the-night,
It's a life of the night,
It's-better-off-read-than-dead,
Words that keep repeating in my head
And it's this fight, this ongoing fight,
And I don't-like-to-fight,
Don't get at me wrong,
I will fight with these words I write,
I-sit-at-night- then-dream-at-night
In these dreams I fight, So-all-my life, I-fight,
It's been this way all my life,
Even in my dreams at night,
Shit ain't right, fighting to bring dreams to reality.
It's been the greatest sin in my life,
The-day-to-day life, so today I write
This is my only escape I have in this life,
How many feel me?
How many feel the real in me?

*Not many not really
I-sit-at-night- then-dream-at-night
I sit alone as I write....
What will I dream about tonight?*

Calls when you love me,

Calls when you feeling me,
Calls when the thoughts of me get to strong,
Calls just to tell me you thinking of me,
Call when you feel I'm all the man you need to please you,
Last lover alive, you can see that shit in my eyes,
And love the attention you give,
Baby you the reason I feel I live,
And I put that on everything
And that real as it gets,
Real shit, feel my mental,
Hood nigga still a good nigga,
Living life and loving life,
Words get so deep,
One day you're going to be my wife,
When that day comes, I know I'm living life right,

Little Wonderful You,

My day was going good till I talked to her,
I was going through the motions,
Then she sent a pic.
(Then a phone call that wasn't you)
My day started turning bad,
The convo turned sad,
Then I got mad,
Little wonderful you,
You stayed your distance,
Waited for me to claim down,
Then you turned my frown around,
A kiss here a kiss there, a kiss cuzz you care.
Little wonderful you,

They say it's not very much beauty in pain, Sit down with me for a while,
I'll listen to your story, then write your pain into eloquence....
When I'm done all that I request is that you "like".

Mental break down,

Then there are those women that just take a man there
I'VE COME TO REALIZE I HATE HOOD BARBIES,
DELETE ME FROM YOUR PAGES
DELETE MY PHONE NUMBER,
I HATE THESE BITCHES,
THAT'S ALL TALK,
AIN'T ABOUT NOTHING,
GOING NOWHERE IN LIFE...,
I'M AIN'T FUCK WITH THESE HOES NO MORE,
BITCH IF YOU AIN'T GOT NO CLASS,
I DON'T WANT YOUR ASS.
THESE BITCHES THAT GOT MORE PURSES THEN SHOES,
BUT AIN'T GOT NO FUCKIN CLUE,
FUCKIN LIKE THEY AIN'T GOT NOTHING TO LOSE,
I AIN'T FUCKIN WITH YOU....
I'VE NEVER BEEN A NIGGA TO FUCK ON RANDOM CHICK
AND I AIN'T GONNA START WITH YOU.
The break down is over....
After writing the mental break down I kind of needed to get back to making love with words,

Sudden thoughts as a posed to a thought

Let me take my time with this one, I need the thoughts to flow like water,
Need that thought of passions to be the melody,
Desires of the heart to be limitless,
Prayers to be heard from the earth to the heavens,
Dreams turning into reality,
I'm telling you all that I need, I'm you telling I'm willing to change my world *for you*

Can I write for you?

It's late and I can't sleep
Got so much on my mind,
Thinking about making love to you!
I want you in my bed tonight,
Damn I want you,
It's been sometime,
And it's true your absence
Got me desiring your presences
I know I got to be patience
Just can't wait till we clear this distances
Want to make love you uncontrolled
I want touch you mind, body and, soul,
Baby, this is my confession,
It's admitting releasing, without teasing,
Want to be pleasing, pleasuring your everything,
Baby I'm writing for you tonight!

I'm always writing for her, Heather that is, I don't have to ask, post the question to let her know I'm thinking about writing something for her tonight, it's the setup for other readers of my works as well, I think people enjoy my writing no matter whom it may appear I'm writing for.

Sudden thoughts all about Carrie my baby girl

Time and what's timeless,
The time spent with baby girl and her pretty eyes
Timeless when I tell her to go bed,
She put Teddy
And sayz Daddy Teddy in bed...
Timeless
Lol No baby you go to bed...
Then she runs off,
Times spent eating ice cream
And her mother screams John don't give her none,
Baby girl still standing waiting for her share,
Timeless when daddy's spoon falls in her mouth,
Daddy's little girl, Daddy's little world of innocents.....
Spending time, cuzz she's mine
Our time, truly timeless!

You're my real Queen,

Hey hello,
Baby you know how I get,
When I get to moving and grooving on this poetic thing,
It's one those times during the day, I got you on my mind, No matter the grind, I got to take time for you, Cuzz with you're in my life, and you take me higher,
I know with me, it am not about what's in my bank account, I appreciate you Miss Lady,
I love getting fly with my Lady on our days out,
We don't need to have 50, 60, grand, to stand out,
We both know, I'm your man you're my woman,
That's what this love's about, that's what this love's about,
Never in love with the money, cuzz its better loving you, Baby this my truth, and I love you had to let you know,
You're my real Queen, I had to let you know, and I had too,

Tears,

For what, I don't have this kind of emotions for nothing,
If I could give you all my love, I would, I don't mean to be spread so thin,
Thin with presents, thin with my presence then again with so much on my mind,
I lied, I was wrong, I didn't mean to be so distance,
Sudden Thoughts, suddenly I'm lost, damn colder than morning Frost,
What are these tears for, Damn I don't want to cry anymore?
Last time, don't want to hurt anymore, how do I even the score,
How many times, how many lies, I need to hear the words,
Not that you know, I need to know, I need to feel that I'm not along,
We need to build this trust again, we need to build this trust again,
Betrayed, not again, I thought we were more than friend,
How many times have you sold my soul, how many secrets have you told,
How many?

I propose that we release and let go, I suppose that's the way love goes,
Cuzz you lied, cuzz you were wrong too,
Another San Bernardino scandal revealed, words got real,
Kissing cuzzions, blood cuzzions, Damn that's family, how could you,
Why would you, damn didn't want to see the truth, blind to the facts,
Friends and family on a good act, am I the only one blind with love,
I guess revenge to get it in, Never would have I crossed that line
Never in Life, I wanted you as my wife, I don't think we could make this right,
Sudden thoughts, Damn Now I'm lost, colder than morning frost,
Tears, for what, I don't have these kind of emotions for nothing,
I want to fight for what you said was already mine, how did I lose you in time,
I got on my grind,
Love you the whole time,
Just couldn't give you as much as you wanted,
But you would've had it in time,

Tears, for what, I don't have this kind of emotions for nothing,

I understand he's your sun right now, I know time goes around
But when the heat of the moment, passed, just know I'm still your blue star,
And I shine, just from a far, looking in on you at night,

How do you ask the sun not to raise

How do you ask the sun not to raise?
How do you ask water not to be wet?
How do you ask the night, not to be dark?
How do you ask the stars not to shine?
You don't, so how can you ask me not to be myself??????
I'm a poet, I was a poet before I ever knew it, and I'll be a poet long after the soul leave this body and comes to its final resting place,
How do you look into my eyes, and ask me to change,
Yet you ask?
I have one request from you, please move mount ZION...
When you do that I'll change........

*People can be complete assholes,
How do I know, I'm one..
But that's beside the point, This poem was inspired by people on Facebook
wanting to change my style of writing,*

I'm like "WHAT" What the hell do people be one dope or dog food..? Johnny you write a lot about relationship why don't you write about something conscious, or spiritual? Wait there's a million poets on Facebook why don't you go find someone that's already writing about that? And leave me the hell alone. And like a sudden thought I got on!

Relationships,

Relationships, women will fall in love with the man that's standing in front of her, then request that same man to change everything that she fell in love with.

One thing I pride myself on when it comes to relationships, I have never trapped woman in a relationship, Here's my reason, I courted the woman, she gave her heart willing, if she decides to leave or doesn't feel the same over time, she free to go.. But once it's over, it's over. Do I have a time frame for when it's over, yes, when my heart no longer wants to try? That time frame isn't measured by times of days weeks or even months. It's measured by emotions fading. And jumping in the bed with some else just to make myself feel worth something isn't and has never been my forte.

Another thing I've never went back to an ex another than just sex. There's a reason we became exes, and most times that reason had something to do with one just giving up on the other, in my book there's no excuses in the world I would give myself to try again with something I know going to fail again.

I just wanted all of you,

I see all of the good in you,
Hoping you don't see all the negativity and me
I knew you were the one I wanted
From the moment I seen you
Baby this is my truth, saying thing I've always said too you, You're so beautiful
I'm glad you opened your heart and let me walk in,
I'm lucky to have you
let me hold you on this moment just for a moment
you're not like any other woman I've ever been with
What makes you so different?
What make me wanna take you from rent,
What makes me wanna make us one family under one mortgage,
Baby with all that I say,
I'm so in love with you it's crazy,
I believe in us, I believe in us,
In our love I trust

New York to Cali Love

I know you can't, and I really shouldn't go there,
And if we start this, I ain't gonna wanna stop,
Living off the thrill of a dare, and ain't far,
This affair this lust this touch, become a secret dance,
Hidden romance, and we're taken this chance,
Tonight blue lights got your body looking amazing,
I wanna lay you down, whisper on lips,
Feel your hips grind on mine, I wanna take my time.
For once I want you to truly feel like your mine,
Go with moment that we're in, feel the passion of the night,
You know I want you, you feel my desires, the body never lies,
Still this alluring proposal, must remain a secret,
Cuzz if this got out, Oh my God, biblical loss of love
Hell has no fury like a woman scorned
Then death to the man that betrays his brother,
Yet and still there's an infatuation to our situation
Neither one of us wants to let this go,
With all the reasons in the world to let go,
There's still emotions between you and I,
Lately they've been getting deeper and deeper

I know you've been feeling the pressure for sure
I love you, I need to feel the touch of your lips,
Baby you and I words deep, my word sneak into your heart, good night!
This one for you and only you tonight!

There were times I was looking a certain someone, someone I was growing close to, Once she hit the like on can I write for you, I began writing for her, and only her., We began an emotional affair, the kind of affair that has emotional consequences, trading songs over in boxes.. What were we doing? We could never have one another, the distance the relationship statuses, yet and still we had us, and I enjoyed every moment even if I couldn't have her in my arms…I had her in my words.

It's a good morning

It's a good morning when waking up and thinking of you
I don't want just your Lips,
I don't want just your neck,
Just your breast,
That little tummy that looks
So yummy,
I don't want just your hips
Or that little sweet kitten, you hides between your thighs...
It all has value,
So true,
What I want is deeper,
Heart, body and soul,
You say there a lock
That I need to find the key,
Well baby, as you know,
I'm a Prison soul.
So now I'm become a thief
Cuzz I can't find that key.
I'm use these words you call beautiful.
To entertain your heart and soul...
So when I take that caramel Heather body to ecstasy,
You're going to thank the thief...

You see, I ain't going to hide these words from you,
Something I can't and ain't going to do...
You see, I'm a grandfather child....

Sex Therapy: counseling session

Sex Therapy: counseling session
She said I've never had an orgasm before, that the few men in her life only pleasured her mentally.
I sat there listening and watching her body movements as she spoke.
Her breathing became heavy, her legs moved nervously with energy.
One foot playing with her other foot's high heel.
She couldn't stay still,
As she spoke of all the things of desire....
She said, all she wanted to do was cum like the women in the porno's
To be excited that she would not only cum she wanted to squirt,
I sat there watching as she fantasized, closing her eyes rubbing her thighs.
She was there, a place in her own mind. I could tell as her voice became whispers of satisfaction, it didn't matter if I was in the room with her, because she was no longer in the room with me....
Just as she was about reach that feelings of pure pleasure, she opened her eyes and said, you know what I mean?
I stood up, walked across the room, placed one hand on her thigh, then bent over and kissed her

in the mouth. I placed my other hand behind her neck, I pulled back from the kiss, looked in her eyes, and whispered are you ready for all that you do desire to come true, in this moment, in this place, in this time?

She looked in my eyes, placed her arms around my body and stood up, give into another kiss, as I slid my hand down her curvaceous body, pulling up her sundress, she wraps her right leg around the left leg, I place my right hand between her thickness, then began to caress her lips with my fingertips, rubbing slowly as she moisten, my fingers steadily moving up and down the outside of her lips, till the point she was so wet, I started playing with her clit, sensations ran through her body,

She moaning, now realizing something that's never happened before is now happening, moans turning into screams, screams turning into biting... I pulled my hand from under her sundress, and walked back across the room sat back down, continued to watch her.

She fixed her clothes then looked over at me, then said Damn Doctor Jones this was a hellva first session. I thought I was just coming to talk.....

Then the doctor's assistant came into the waiting room, then said: Mr. Frost, Dr Jones will see you now! Mrs. Smith, she'll be with you soon...
She looked over at me with a smile then said to the assistant, that's alright. I think I've figure it all out. Tell the doctor I'm giving a day of full pay. Good day to you Mr. Frost.
I smiled as she walked out the door!

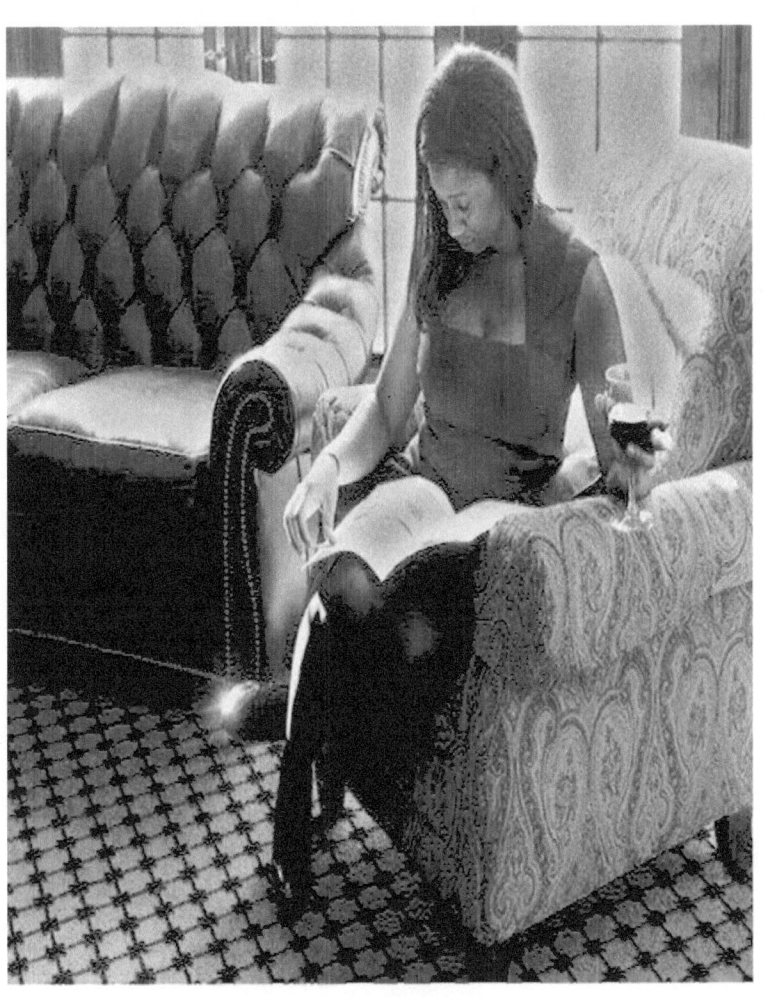

It would not have been me if I don't place this story in my sudden thoughts,

Writing and letting your mind run wild, the things a woman can do to man when just watching them do the simplest things...

When sinner makes request,

Lord I'm going to ask you for forgiveness now,
Cuzz I know in the next few months, I'm going to lose my faith in you,
I'm going to blame you, I'm going to turn my back on you,
I'm going to do things way outta my realm of behavior,
I know you're going to know why,
I know you're not going to let me go through any situation alone, still in the same,
You knew Johnny Frost before John became Johnny Frost,
Mortal Man, yes I am,
Forgive me now and never leave me alone, Lord,
Cuzz when I have nothing else, all I need is you.
Walk with me!
Amen!
O
Sometimes praying ain't enough. And people will test every part of your soul,
O

From Pen to Mic,
From Pen to Mic, the night fades and the mic quite
it's back to the pen, the thoughts never fade,
Everyday a trying day, projects becomes the subject
Subjects become questions intentions get questioned,
Words start to fall apart into different dimensions,
What started out as good intentions, with great ambitions,
Everything seem to flip sides, how you look for the bright side
when there's no light, I guess it comes down to that blinded faith,
The good side said keep up with the good chase,
The other side ain't never got nothing positive to say,
willing to say any ole thang

like crabs in a barrel nigga's willing keep a whole generation stagnant,

Welcome to the real afflictions, infectious states of minds,
people that only care about personal shine, the worst addictions,
I have a predictions, those that are self-severing never deserving.
Living on a yearning, will remain the same, the truth colder than my last name!
So know when this Pen to Mic hit stages,
you feel all the intensity in this write, I put that on my life!

I was once told something

I was once told something, that I see come to light,
Johnny the most unlikely people will support you, and those that you expect to support you will only support you when they expect something. Never do something to expect something in return, if you're going to do anything do it with a passion, let that passion always come from your heart!
I was about 17 when I was told this, in the most compromising position with an older woman, looking back I think I learned two lessons that night.
When life is pulling me in so many directions, which way do I go to the light to the dark?
Just show me a path,
Never one for depression
even though life can be stressing,
Do I go left, or do I go right
I believe I'm one of your living blessing

Don't be afraid to take control of your own destiny,
but once you chose to take this path,
you'll see the closest people to your heart will doubt everything you do,

but it's not out of fear, it's out of love, understand they don't want to see you fail.
Still understand that you can't let their fears become your fears
Cuzz when success or failure come these same people will be the same people to hug you outta that same love...
This life, this journey is yours and only yours!

Defining myself while at the same time finding myself.

Sometimes I guess, the love is only for the good words of passion and not for the moment to moment emotions of life, giving the simplicity of loving, but sometimes that gets lost in the words, I must remember to wine and dine the lines, for my craft expect no less than perfection, even though I not a political writer, my skin is my sin, so I have political issues of passion which bring out the need for expression. Defining myself while at the same time finding myself.

I'm not an activist, yet my mind and pen stays active,
I'm no longer just another person posting poems
I'm a poet, I'm a son, big brother, big truck driver, lover like no other,

I'm an Author now, and with saying that come with responsibility,,

People truly do look at you different, and it's not always a good thing,

Learning lessons about this blessing,

For I know I'll be judge, criticized, and downright thrown in the mud,
There will be some that will love and support,
My responsibility for myself, is to stay in control of my ego,
Staying humble is truly a must, well how do I do that,
I stay with my family and friends, and only reach out, to those who reach out! Still knowing growth is that great change that has to come within self.
I'm not an activist, yet my mind and pen stays active

I want you tonight,

let's take a drive where there's no city lights,
I want you in my arms, in the fresh of the night,
I want you, in a place where It's just you and I,
I want you to feel the passion in this write,
(Whispers) I want you, I want you, I want you,
I need you to know that these words are for you,
I know it's been sometime since I got a chance to write for you,
I know it's been crazy these last few nights,
I know haven't been affectionate as a man should be,
I know you've been really patience with me,
(whispers) I know I know I know,
You have to know, these words are for you,
You have to know these spill of expression come from my heart and soul.
You have to know, you're the only woman in my heart and soul
you have to know, that I'm loving you forever more,
you have to know, that you are the one for me,
(whispers) you have to know, you have to know, you have to know

My Love, my poetic angel,

I come to you the only way you allow me,
My presence, come through time and space,
My picture, was a reminder of who sharing a caring space within you...
The my words bring my essences to you,
The strength of survival, allure you,
A mortal man yes I AM,
My words have immortal powers,
They can wipe the tears away,
Touch you in so many ways
Caress your soul while making love to your mind.
But these words are nothing compare to my touch...
You said you wept, I felt it...
Cuzz even in your fantasy, I feel you in my reality...
Whenever your ink touches cyber space,
I'm feeling you. Wanting you holding you...
Wanting to be the only Poet severing you
Desiring you, wanting to be deserving of you,
Escaping into you...
As if each word you write to all them other poets,
Were only meant for me,
Saying all the thing you really want to say to me.
Then with a push of a face book "like",
It's over, and you're gone.....

And I'm weeping and thinking,
We could never be...
No...... Matter....... how..... Much, we, chat,
We may never get our chance to go beyond that....
I never shouldn't have fallen in love with you....
DAMN!!!!!

You ever want freedom

You ever want freedom so bad,
From any situation,
You feel it, can't have it, and desire it,
So much to the point you're damn never lusting for it?
I was there
Just a few moments ago,
There were times I couldn't see the light at the end of the tunnel,
Still I stayed ambitious,
Wrote poetry from my heart,
My expression became my art
When I started there were no Facebook friends,
Some never knew about the child abuse,
Tears I used till the moments
My Aunt Mary Ann came took me home,
She became Mommies and got my sister and I outta the system.
25 years later, I would returned to the system,
Seven more years of my life I would give 'em,
Bad choices in life, consequence and the sentences
Lost everything in life,
With every woman in my past life,
Didn't even have the smiles of my child,

Lusting for freedom, Expression became my art from the heart....
As of April 28, 2014, I'm no longer report to the Federal Government
In confessions there are lessons, I'm blessed

Only a few know what I mean!

Only a few know what I mean! (I might not)
I been sitting here thinking,
I might not reach a few of my goals,
I might not reach old age,
Nothing promised in this life,
I might not ever get married and have a wife,
I might not make love to a million women before I die,
I might not ever finish this book of mine
Cuzz nothing promised in life,
I might not wake up tomorrow,
But there's faith and love in life,
I got 'em both and that's no lie,
One thing no one can ever say about me,
That I didn't try,
Can't say I didn't stand like a man in life,
I'm keep it One Hundred till the day I die,
I might not live to see the next black president,
I might not live to see my children's children cry,
I might not live to see my other daughter again,
That last one, an admission, I admit with a mental gun on mind...
She stay on my mind... So I stay in pain
I say it with a heavy heart every time,
Only few know what I mean,

I've lived this life the best I could
I wake everyday try and try...
The devil lived, I've lived till I've seen the devil cry
behind a vile of evil...
They say men don't cry! That's a lie,
Ain't gonna lie, I've lived hard times

So scared I cried

So many times in my life I was so scared I cried...
Only a few know what I mean, the lord knows my pain...
Gave my testimony to Facebook so many time,
No one ever pays attention till I'm writing about fucking and texting, sexing
So I know what's on people minds
And I tend to play to what's on most people mind,
But tonight I'm state some facts that's been on my mind,
And doesn't matter if one person push the like,
I might not make through the night,
I might not make it to the next lady in my life,
I might not ever speak to my father ever again
I'ma write, cuzz this shit been on my mind,
Been driving to work as of late, no radio, no one on my cell phone,
Just thinking, coming home drinking to all the shit that's going on in my mind,

12 hours,

Last night I went to sleep for 12 hours,
Woke up this morning made love to a tender flower,
Then got in the shower,
Tonight we fight, cuzz bullshit in Facebook groups,
But only a few know what I mean...
Wonder why she stays with me?
I would a been left me but I guess I got her Loyalty,
Kinda of a fucked up reality,
But I wouldn't trade my life for yours,
Cuzz I surly don't know what the Lord asked you to live through,
I got one life to live, so I won't judge yours...
All I ask, is that you know what I mean when I say don't fuck me today!
I gotta lotta shit on my mind,
I just don't have time for the bullshit that on yours,
Only a few know what I mean...

I have a new Friend,, Her Name is Passion, She's beautiful Nothing like Heather,
Time passing and we are getting to know each other, as friend and Lovers,
Don't tell Heather cuzz I still love her!

Reality speaks

I was asked to write a Father day poem ,,,
I can't do that,
when I don't have a relationship with my father,
been his greatest disappointment since the
moment I was born,
so the love there been always distanced,
Yeah I kind of feeling kinda scorn, I was warned,
My mother that raised me,
one day told me she was proud of me,
that came outta the blue,
Needed to hear that,
it keeps a grown man emotions outta the blues,
it's the little words that keep you true,
Reality speaks
When I got nothing,
I got poetry, and all of yuzu's
So you know words mean a lot to me,
And if you really knew me,
I mean the real me,
not the Facebook Johnny,
You know my circle smaller than all of y'all
I don't let too many people get too close to me,
Too many people really out to hurt, that's reality,
so if you ever spoken with me,

It's a trust that I don't give most,
Reality speaks

Over the years my relationship with my Father was off and on, I guess like any family, as of late things have been going good, and No matter what I love my Father

She's Our Love child

They say the lord never make a mistake,
It's blessing, it's fate,
And the only way we going to make it
We both got to have faith
Faith in his words,
Faith in each other words,
That night that leaded to the morning,
somewhere between here and there,
our love paired,
Life came into conception,
And from there,
our future would be forever paired,
Not our plans, Not our desires,
Our love Child,
She has your lips, your smiles, your eyes,
your ways, your walk, your sounds.
What you'll teach her
How to be a woman,
What I'll show her
How a man take care of a woman
What you'll teach her
How to care for her body,
What I'll show her
To respect her body.

*Our roles are set for the rest of her life,
you're mother I'm father,
She's Our Love child............
There something to be said about love
Love can change a man life,
Love can take a man to the levels
He's never seen within himself,
Love can be a blinded focus
Faith within an addiction,
A high that so unnatural and it's still legal,
When that love comes around,
He'll surrender his heart, mind and body into commitment,
There's something to be said about love,
She's not like karma,
She's not looking to rule or get revenge
She's there for a healing,
She's willing to fight the good fight,
She's willing to be the teacher and the student
She's love, you can't mistake her, and you can't compare her,
She's understanding, wisdom, and a true blessing,
And even doe I've never met her for myself, I've heard so much about her, why do I say this,
Cuzz EVERY woman from my mother to my children's mothers,*

From any woman that's ever came into my life, has conceal her identity as love. She's not real, Cuzz if she was she wouldn't dare distance herself....
These are my words not meme's, what are yours? I just want love to fight for me as much as I love for her!

Something changing

Something changing within myself again, I'm starting to live more, not afraid to go outta the house, these last few week have been a trip, from my car being stolen to the P. O. threatening to violate me again for taking out a loan this time, still in yet I was able to take the girls out for a good time, Dodger game, swimming and started their school shopping, Loan paid, Rent paid, car note paid, child support paid, cell phone paid, light and gas paid.... yeah I'm broke, but I'm broke paid... I'm blessed, things are starting to look better, and I still have two court dates to handle this year, so as for now I'm focused...
I'm far from rich, but I'm rich in wisdom and its take wisdom to move through this life, that wisdom comes from a lot of prayers.
I thought when I got out of prison that it would be easy to get my life back, the life I had I no longer want or need, I'm building a new life, moving forward!
A lot of people cut me off when I went to prison, a lot of people was glad to see me fail, some of those same people waiting to see me fall again.
I learned my lesson. With age you come to know this, not everyone your friend and not everyone

that say they are happy for you, are really happy for you. Here where the wisdom come in at, Most times these are the very same people that struggle with you...My circle is small, very small, and just not everyone's allow in, that includes family as well.
I love you for who you are not what you are or have! That's "MY" train of thought, and it's not for everyone!

Tripping on silly things,

You haven't seen me flirt with anyone on my page in a while,
I've been falling in Love with you,
Saying good-bye to my past,
Looking to you as a part of my future,
Never did we think we'd be caring for each other this way,
Time flying by, it's almost a year dealing with you,
I know you got fans just like I do,
Yet I choose you, Baby,
I am not saying anything you don't know,
Yeah we're moving slow,
But I am not got a problem letting the world know I'm dealing with you,
I'm falling in love with and I don't care what the world got to say,
I think you're an amazing woman,
But if you want me to chase another woman,
Remember I'm the Greatest Lover to ever touch the pages of Facebook,
I can have ANY WOMAN I WANT, THERE'S NOT A WOMAN I CAN'T HAVE!
MY NAME JOHNNY ALLEN PHILLIPS FROST!
I'm in love with you Miss Heather, and I'm not talking about your mother!

I love you, even when you got over 60 likes on your pics
And some muscle bound jerk about to get his feeling hurt...
I'm not about to keep putting up with this fool,
Call me what you want, just don't call me late for my dinner plate....
I am not got to much more to say,
And I like your hair this way!

There are time that I can't see passed my own ego, as well as there are times that I don't realize my own potential! The duality of life, can sometimes be confusing. Knowing your balance for growth, must be the key,Be determined, as well as humble!

If I lost you,

If I lost you it wasn't cuzz I didn't put up a good enough fight.
Its cuzz love fell from out of sight.
Desperate words couldn't find it mark each night.
Expressions of poetry dripped.
With each line dropped the words lost meaning.
So love faded from an unforgiveable mistake.
If was true love then love would have forgave. And a great lesson would have taken its place.
But then again times have changed.
And the definition of love is no longer the same.

There a time

There a time to take action,
There's a time to speak,
There's a time to listen,
There's a time to pay attention,
This is that time,
Whatever I learn after this time is over,
I'll give my reaction,
Who am I again?
I don't know,
My name changed
My identity,
Based off numbers,
Everything from
House phone numbers
Cellphone numbers
Security numbers
Bank card number
Employee numbers
Federal penitentiary numbers
Who am I again?
I'm number 3152-112-909-827-6904-112,

They say men never pay attention

They say men never pay attention to the little changes that a woman makes about herself,
I pay attention to all the little details of pain you go through to look beautiful for me,
Last week your hair was straight, this week you've curled one side, arched your eyes, changed the color of your eyes shadow, stop wearing lip color started wearing lip gloss, you went from wear hoops ear rings to wearing nothing,
Baby I pay attention,
This morning you woke up just to watch me sleep, gave me a kiss to wake me,
Good morning
Middle of the day at work, thinking about you,
Wish I was at home in bed with you,
Making love to you,
Caressing you holding you,
Just wanting this time with you,
Middle of my work day,
Yet. I can't stop thinking about you.
Is it love or is it lust,
It's that desired passion
That's only happens between us....
Good afternoon baby...

It's the end of the day,
I'm on my way home to you,
I have no worries
I know dinner will be cooked when I get there,
I know you'll have on something sexy on
I know that you have my clothes ready for me to get in the shower,
I know these things because you care about me,
It's my Friday
We'll in the bed eating dinner soon
Watching movie,
Then making love
This is our passion
This is our lust
This is how we make love to each other
It's give and take relationship
It's not perfect
Still and yet we enjoy each other
I'll see you when I get home babys
I can't be with you today,,,
but I'll be with you soon,,
when I get there,,
I'll make love to you all new,,
I promise you,,
if you need anything emotionally,
just think of me,
Holding you

*Just know that I'm thinking of you,,
holding you in my arms real soon...
No matter the distances,,,
My love will travel for you!!!!!!!!!!!,,,*

I'm alone again

About to take a break from all the nose
Let the sounds of other wanting attention,
Fade into the black and white fuzz of nothing,
Sit in my own mind,
Resolve my own desires,
Confront my own confusions
Get a better understanding,
I'm alone again
Even with everyone that's around me,
I'm finding myself unhappy, lost, hurting,
Praying, laying in the bitter tears of prayers,
My soul asking for questions,
Self-image missing,
Abandon, invisible, emotions uncontrollable.
I'm alone again

Pay attention to our connection,

When you're feeling some kind of way,
I'm feeling some kind of way,
Your monthly come, they becomes my headaches,
Your happiness, become my smile,
When you're feeling sexy, I'm getting horny,
When you're in intense thoughts, my poetry gets deep,
And when,
I'm calling you, your calling me,
We both go to voice mail,
We say the same things,
I was just thinking about you.
I wait for you to call me, and you do the same,
You wait longer, I call and get through....
Oh yeah I like your hair too,

My Art Been the Same

My art been the same for months now,
Lord is this the best I got?
I want to go to the next level,
I'm bored,
Have nothing interesting to say,
My words by far have been meek,
For weeks now,
Everything I say seem weak,
I think I'm looking for meaning,
The sounds from around don't seek inspiration,
Determination has no destination,
I'm craving,
I'm pregnant with art as my child,
Words born as a wild child
My thoughts rambling,
Reaching, not teaching,
I'm in the middle of seeking,
Looking inside of myself, begging, praying,
For something to change within me,
The Ghost of an angel,
Born into a man,
Sinned into a demon,
Saying phrases no one understands,
Am I going crazy?

*My poetry seem cursed,
It needs a cure for sure,
Where do I stand?
Lost is the man,
Dreams have no meaning,
Am I awoke mentally or have I falling asleep?
It seem like I've lost my flow,
Looking for my release and let go,
Looking for my inspirational light,
Kind of need in this life,
What will I do if I'm not able to write?
My ambition seem to be the baby inside crying for light,
SCREAMING WRITE WRITE!
Yet I have no poetry to write,
So I'm say good night!*

Speaking inner thoughts

Words written, speaking inner thoughts,
Death is prefect, why, anything living must die,
Doesn't mean with the loss of life, someone will cry!
Society lies, prayers fall short in the light,
So many doing anything just to survive,
Love scatters, nothing really matter,
I wondering will there be a light of hope at the end of this poem,
How could it, I've been introduce to my dark side,
Testifying about the other side of life,
I won't lie, I once lived across the street from a woman getting beat,
I did nothing, but listen, wasn't my business...
I remember her name, Kim, for weeks we'd heard her cries....
This woman was so beautiful, let me be truthful...
She once came outside, and stopped time,
The Lady dressed in white, all she did was check the mail,
The same night, we would hear her cries,
I could hear fist beating, she was screaming about the nigga cheating...
Never forget the day she finally said she's leaving,

*Her home-gurl came over in a blue ride, and change her best friend's life.
Months later, I seen Kim, at the Legion on the west-side of life...
She was looking amazing and it was kinda crazy, Cuzz she wasn't the same lady.....
I told her about the story about stopping time, How everyone stop doing what they were doing just to look over at her,
She only remember the dress, I bought her a drank, dance with her one time,
Never to see her again in life...............
If you know where these post are going then you won't read any of 'em...
What a difference a year makes*

*I spent these last few days looking back, at a past love of mine,
And what a difference a year makes, love and heart break,
What does it take to tell this tale, the moment never last forever?
Growth and pain, love and gain, everything must change,
Life never stays the same, why didn't I get her to take my last name,*

*They say it's better to love and lost, than to never loved at all,
Let me tell y'all, I've loved her so deep, tears creep, and I can hardly speak,
That's love gain and lost, and that's colder than morning Frost,*

Across my mind

Then sudden thoughts came across my mind,
What does it take to get over heart break?
Time and faith, time and faith that's what it takes,
What a difference a year makes, love and faith someone just so happen, I wasn't looking, someone just so happen,
And all that heart break just so happen to fade away,
My life feel like a Tim McGraw song,
I'm living like I'm dying, flying on a natural high, I can't believe this is my life, blessed each time I open my eyes,
Loving deeper, speaking sweeter, romancing while dancing under the moonlight,
Man I can't believe all the good that's going on in my life,
Light bright if we keep moving this way, you're going to be my wife,

I tell you, looking back on my life, what a difference a year makes,

I never loved her,

She said the whole time we were together I never loved her,
Words like that kind of hurt, let me put a truth to the world,
Now, never in my life have I slept hand and hand,
After our bodies were intertwined, our finger would in-lock,
Wake up go work, days fly bye, rush home,
Come home, and damn it was on,
Cuzz all she had on was T-shirt, and sing a pretty song,
We'd love like it's our first and last time,
She would scream in her dreams,
From watching scary movies,
Held her extra close to letting her know it's just a dream,
She and I were reality,
Love sometimes moves slowly,
More and more, I'm letting go,

Stage six,

Doing without any other women this time,
Hopefully I come outta of this with a better state of mind,
With the truth and the lies, words spread through groups,
Nigga's and hoe's jumping through hoops
Just to be the next to you
And sorry to say me too,
But I guess its ok cuzz never again can it be me and you!
But don't ever tell the world again I never loved you,
Just tell the truth, it didn't work between me and you!

Stage Seven,

It took time and a friend, to understand, that everything I was giving
Was right, that I didn't have to blame myself, for a relationship that wasn't right,
Love and life has its seasons and reasons,
Don't let emotions take control of my soul, forgive and let go,
Heal, let the truth come me she'll be ready to listen when it's time to bare my soul,
The questions I would have, how could a love so good go so wrong?
How could all the love songs, be song so wrong
Heather beauty would just listen, not try and fix, just listen, be a friend.
Baring pain, venting, she become the physical ear of the lord listening to prayers...
At the time that's all I needed,

Stage eight,

Ok I got my dance and wiggle back, swagger on right,
Just when I thought it was play the game all day and night,
Love came a knocking, and I really really tried to push love to the side,
Without knowing, I was willing to meet her anywhere in life,
You see we went from friends to lovers to friends to lover's friends, Lover again.
All I want to do is ride down south to get to you,
Baby tonight I want to thank you for always being there for me like you do,
I make this promise I won't do anything to lose you,
Your friendship I cherish, your love I treasure, that's for sure...
You're my girl, never no argument that we can't get passed,
Damn I feel like this love's going to last, like forever ever, forever ever.....
O As always you're a blessing in my life O

Breaking up to make up, you know what they say about fools and games

Losing

Friends losing friends, family losing family,
So much mourning, tears falling, so much pain in the world today,
Cherish each moment you have with love ones, Never forget, hold each memory,
Friend of a friend, never give in,
Live life, try our best to do it right,
Love and forgive, treasure the happiness in each moment,
Love out loud, stand on a mountain, and stand proud
For the only thing that lasted forever,
Even when it's as light as a feather, is love that never feathers,
This poem been coming for some time, to many of my friends have lost love ones this year, and silently tears fell from my eyes reading each ones post There's only so much any of us can do, pray send condolences, And sometimes, that doesn't seem enough. I love you all, this is more truth than I've post all month,

My love for Heather

I started express my love for Heather, the distance between us wasn't just physical,
It became emotional as well, Sudden Thoughts, of Heather
It's my heart, it's your love,
I design this heart of mine any way your love wants it,
Once I give you my heart, it's yours, you don't have to compete with another for my love,
But you got to want it, you got to take care of it, never hurt it,
All I ask is that you love me now and never ever let me go......
I hope I'm not asking too much?
I was hoping she was reading my words, seeing into my desires Heather beauty,
Yet I question where this relationship was really going?
What's love got to do with it?
When friendship and relationships cross lines,
Asking question about situations
Which should be more relevant,
The love that was supposed to be haven't sent,
A friendship that's irrelevant to a marriage,
Suspicions and theories when there's no mystery,
Bullshit built up when everything misconceived

*When trust is lost, what do you believe?
Anything you want to believe, the rose bleeds,
Insecurities are a reality, so is loyalty,
Sometimes the prizes get blurred over time,
If it's time and love, then somewhere there was faith and hope!
Got to learn to get back to whatever it was, if was true love,
What's love got to do with it??? Everything
Love= history,
Love= faith,
Love= companionship
Love= friendship,
Love= the foundation
Loving everything about the person that came into your life,
That's what love got to do with it!
I was trying to prove to Heather that I had fallen in love with her and only her,
That I had let these others go, and my babies mama's for that fact, yet things were getting out of my control. And the distance wasn't helping.
I want to know if we're at the point of giving up,
I need you, I don't want to even think that, that we even exhausted our chances*

of being together forever,, Baby I've been out there, and, I've had good,,, and I've had you,, there's no better,, Let me find a way to clean this mess up,,, please just give me a little time,, let me get all these words outta of my mind,, I'm down on my knees, please hear me, I don't want to give you up just yet,, Not yet,, I need you just one last time, just once more,,, I want you last time for the rest of my life,, can you do that for me,,, Baby please,, I don't want to give up on you,, on me,, on we pleeeease..

I know you hear my needs, I missed up, cuzz it was what I thought I needed,

She has ties to me, she and me, the babies,, I had to give it a chance, but found out there was no romance, I got to missing you desperately, Tell me it's not too late, to fit it this, You have no reason, to give me another chance, But I just believe that there no other woman better for me, I miss your smile,, Baby I'm willing to walk the miles...

Please tell me, that you aren't willing to walk away from me...

Baby look in my eyes,

Please don't separate your emotions from what possibly the best love the two of us has ever experienced....

No matter my begging and pleading through poetry, my words went unread, love at a loss of hope, yet the moment I wasn't paying attention, this is what happen next. I started drinking then thinking....

Woke up after a drunken night...

I might be doing too much chasing. Too many women. My phone going off at the wrong times confusing names playing the game losing my mind. The young women bitching, the older women teasing I'm losing reasoning. Still ain't fucking but one... And they all stay on my mind... Cell blown up with pic of chicks that I will never touch or fuck. What the fuck am I really doing with my time??? Ladies' man or man whore?? Don't know the difference anymore.

Heather and I are through, so what do I do, I turn back to my safe zone,
Passion,

Passion, and I are meeting up, we make up excuse to see each other, seeing that we both live in the same area, and one time lovers one time friends. Why not?

Here how it starts,
I want you

Passion: Smdh....hit me later

Why it always got to be later with you?

Passion, because I'm busy smoking a blunt,

That's the reason we never get shit done, bye,

Passion, whatever,

Two hours later,

Passion, now....yo ass ain't sleep...neither am I...so witcha want again?

Johnny: Chilin writing,

Passion, what woman you writing about now?

Johnny: Why? And how do you know it's about a woman?

Passion, it's always about some woman.

Johnny It ain't about you,

Passion, did I say it was,

Johnny so why does it matter?

Passion, it really doesn't, you want to go out to eat I'm paying?

*Johnny Lmao yea, ok,
I know how that sounds*

We did what we did,

And I know it's over,
But really I wouldn't mind
Being your lover,
But there's some problems,
I kind of still love her,
I know how that sounds, Kind of off,
Then there's the jump-off,
Baby I'm kind of a playa,
I know how that sounds,
But I'm coming clean to you now
About my get down,
Too old to be playing these games now
I know, I know, I know,
But don't know how things got so kind-of-outta-control. Kind of like how these feeling for you know, I-just-wanted-to-let-you-know,
And it's freeing my soul, just letting you know
Thinking you're going to let me go,
Just trying to make it right,

There this strange thing I do when I'm breaking up with a woman and moving on to the next, I start cheating, I know how bad that sounds, but I'm one person that can't stand for my heart to be broken and no one there to take care of it for me. To get over one woman I do better to get under the next? I don't know, I just find my doing things with women sometimes I don't even understand.

Love me, that's all I want,

Need me is all I want,

Let me take care of you, that's all I need

Baby I need you to read my words tonight...

Cuzz you ain't answering yo phone all night,
I've been calling all night,
I was going to let you know,
I just didn't know
I'd have all these emotions escaping from my soul,
I know how that sounds, I know...
Cuzz you ain't answering your phone all night,
I've been calling all night,
I was gonna let you know,
I just didn't know
I'd have all these emotions escaping from my soul,
I know how that sounds, I know...
The roles have been which and what I once owe has been repaid,
We sleep in the same bed, but the emotions has changed,
Time doesn't always heals,
I know I don't love her,
And the friendship barely remains,
Times don't always heals
Sometime time creates pain,
Going insane, it's a sacrifice we make in life
Trying to do what's right,
I don't hold her, there's no sex,

I don't worry about putting emotions into her,
This is the furthest setting from a happy home,
Still and yet she was there for me,
In the death of our friendship still there our child
And she's all that matters
I wanted to push you out,
Wanted to never be with you again,
But you came back,
I said, I was done with you,
I signed you, off
And here you are again,
More inspiring
More committed
I wanted nothing else to do with you
You insect that you are a part of me
You won't let me go
You come to me more faithful than anyone-I have ever known
You are a gift and curse
Coming to me in my woken days
My sleepless nights
And in my passionate dreams
This marriage before I ever come to realize,
Who I am, as a man, as black man, as a father, as a son, as a life.
The Lord, gave you as a gift for me,

*To use to share, to cope, to bring joy, pain, and hope.
Poetry, you are forever a part of me...*

I'm always calling out, but this time it's more than one person that's watching, my mental affairs were getting out of control, these affairs I would have with women across social media,
I'm writing for New York and two in Cali!

Like a sudden thought, I'm on to the next

What good to us

Sometime we want what good to us,
And not what's good for us,
Wanting never to hurt or feel pain,
Pushing for the fantasy
Not looking at what we already have,
I read someone post once
"People let you know where they stand with you by what they do and don't in your life,"
I believe this to be true depending on circumstances, not everyone that love someone can always be there for us,
Love is, what, love does,
That doesn't mean, just being, there for someone, that means being strong enough to forgive when that someone can't, be there for you, for whatever the reason.
This life is short,
This life is a gift,
This life is a blessing
And wanting the world to be prefect
Will never happen...
To thee known self to be true.

Playing games looking for that one,

Watch how you make women fall in love with you,
Playing games looking for that one,
Too many falling,
Then ain't none of them calling,
And even do you sleeping alone,
One of them ladies really want to be all up in your home,
You keep going the way you going,
Death at the hands of the woman that truly love you,
Johnny Frost the Greatest lover to ever touch the pages of Facebook,
Going to be
Johnny Frost the deadest Lover to ever touch the pages of Facebook,
Slow down,
Pay attention, not all these women care about your well-being,
Nigga you really need to start thinking,
Step back and look at each situation.....
She love you, cuzz she just broke up with her man,
She Love you, and you don't even understand.
She love you, but doesn't know anything about you,
She love you, Cuzz she has nothing better to do

*She love you, and doesn't have a clue,
She love you, cuzz spending time with her is spending with her,
Johnny not one of these women really love you!
My nigga you sleep alone at night, get a fucking clue!*

Silence for no reason, means a change in emotions, that's just how I feel,

The night I should been by your side, Part 2

I was on some get rich shit slick shit,
If I was holding you, listening to love songs,
I would a never heard gun-shots and seen my boy drop,
Down the line, on the grind, white powder money,
Damn I wouldn't have had handcuffs on, from returning shots,
Cuzz these niggas in the streets don't play fair,
Why these fools had to get there?
How many mother had to cry that night,
It's the street life, and it ain't right,
No such thing as fast money,
Had to learn from the school of hard knocks,
I should of been my your side, now I'm closing my eyes doing time,
Will you stay in my life as I stay in my lane, while trying not to go insane?
So many emotions running through my mind,
Jay-z never lied, it's a hard knock life,
Doing this time, it's changing my state of mind
None of this shit should be glorified, 52 months, fed time,
Damn I should be by your side,

It's a morning wake up, chow time, then a call to the streets,
What's new in the world, calling baby girls, it hurt to hear voices,
At this point I got no choices,
Then the ghetto reports,
Found out you've move on after six months,
Some Cat from the west-side of life, or should I say from the other side,
Damn the love of mine crossed enemy lines
Got that nigga taking care of what's mine,
Damn it should be me by your side,
I want to take bullshit back, at this point life's getting to me,
I feel cheated, and defeated,
How many times do I want to make phones calls to the streets?
To my nigga's that don't care at all,
Go there take your ass and kill his ass
My real Nigga's told me just take shit as a lost,
Learn from the lessons, and try not stress at all,
That I'm in the true church now,
So I started to pray, I mean I'm praying,
Looking for signs on which way to go,
All my life I've had a stone heart,
Bad choices have me going my own way,

*Lord only knows,
Sitting here doing this time
There a reality to my vision now,
It's up to me now to hold it down,
Win lose or draw, it'll be on me now,
Just get in a zone and don't let go,
Still I wish I was by your side,
Going to church every Sunday,
Not just about the preaching of the words,
But actually living the words,
God blesses the positives,
I still gotta pay attention to the negatives
Cuzz it's all a part of the business,
What time will do, make you grow up,
Too bad I had to lose it all, including you,
No longer living with my eyes wide open shut,
I shouda been by your side that night.......*
NOT A TRUE STORY, WELL PARTS OF IT IS, YOU FIGURE IT OUT!

My page,

I don't know what you see when you look at my page,
I don't really worry too much about what you see,
And even doe, you're getting a part of me, or should I say a lot of me,
I'm still be me, my heart won't change,
That's the only thing that stays the same,
Everybody may not agree with everything I say,
Don't worry I don't agree with too much of what y'all say,
And I never pay attention to what they say
CUZZ THEY TEND TO SAY A LOT OF NOTHING,
Damn that last line sounded like a drake line,
Don't worry it's all mine, no lie, no lie, no lie,
I'm living life, and for the first time I'm living right,
My ambitions on a missions, believe or not, I'm praying,
Yeah doing more than just saying this, really living this,
I don't know what you see when you come to my page,
I don't really worry too much about what you see,
Now I get to steal a line, only god can judge me,
It's funny who inspires us, in this life of ours,

This just one of them feel good poems,
I ain't drinking, just thinking, feeling good,
Feeling better than I want better than most ever could, but should
Man I'm thinking this the best poem I've ever wrote,
Or this is the best feeling I've had in a long while,
Did this poem make someone smile other than myself?
Now I'm worried about what you see on my page, lol

I need to talk to someone,

I would call you,
But I know where that convo would lead,
So I'm outta luck, but it's like not you would give a fuck,
Feel like I'm living this life without real love,
I would call you, but then that'll be crossing lines
Seen something that would change my state of mind,
Damn words sleep while I watched desires creep,
The shit you see on Facebook,
Ain't always a good look?
The artist in me, feel like I'm always cheating,
Even doe there no late night creeping
Although there could be, interesting,
I would call you, But if it ever got out, so many emotions lose control,
Everyone would know, then my poetry would become cheap
Even doe I'm writing from my soul,
Words so fine, now everyone's thinking I'm dropping lines,
Only a few understand this state of mind,
I need to talk to someone,
Cuzz ready I'm hurting,

I would call Heather but she's am not been picking up her phone,
So I got this feeling all alone,
I would call Phoenix, but lately she am not been feeling me,
I would call Heather beauty but truly, white sand beach been her thing,
I mean I would call DC, I know where that convo would lead,
Life changes day to day, it's all really a mystery to me,
I must admit sometimes I see things crystal clear,
What I've learned over the years,
Real friendships will always be there,
Funny thing about this, no one there's when your shedding tears,
I would call you, cuzz I really need someone to talk too!

Why?

I had wrote this poem a few years back, never posted it. Why?
Well you'll see why, writing into the fantasy of life, Question, without harmony
Loves not real, or do you have to have skills to love so real,
What's the reason the heart wants to be love?
What comfort does the heart get by getting broken and repair over and over again?
Why is it frowned upon, when a man shows his emotions so openly,
If love is illogical, and women are sensitive with emotions why are we as men so allured?
Cherished friendship seem to last longer than real relationships,
Marriage seem scary, yet no one wants to live alone,
Late night creeps are cheap, spending one good night with a Queen seem like a dream.
Sex is an addiction, love is an affliction that's so infectious, Yet no one minds the connection,
Life can be so mysterious.......
Am I lost or am I in love with the thought of being in love?

I was thinking about you today,

Kinda got emotional,
Thinking about all I want in a woman lies within you, Words cries, as I try to express what you mean to me,
When I'm near you, I can never get the words,
Nights without you in my life,
How I want you by my side,
All I desire, all I want, all I need,
I fall weak, in the knees when you tell me you love,
Because it's a tease to me, because I know that we can't be,
There are times I think about you so much,
I know I need to get some self-control,
I know I need to love you enough to let you go,
But my soul doesn't knows, no better,
My heart wants to love you now and forever,
I know I got to get it together,
Cuzz loving you is wrong,
And this ain't no song, Cuzz there no way this love could ever be right!
Not only do you have a man in your life, you're his wife,
There's no way I should be writing these words for you tonight!

What else am I to do, it's a poetic night, and I got you on my mind tonight,
So I write, the reason I'm the Poetic Knight!

I stopped writing for a while till then this came out I've been reading more poets as of late, trying to gain my love of poetry again, I went to few unnamed poets, I mean their big name poets, I just won't mention names, cuzz really they may be ashamed to even know my name, Kind of sad, where the support in the poetry game,

I want to know,

I mean this ain't the rap game, why we got to battle each other
I want to know why we can't get on one deep flow,
I want to know, where the real support goes,
If I ain't apart of team, why I'm just some off band poet, Why,
Why my doe's poetry have to be judge, by people that don't even read,
I want to know why Speaking to the Next didn't go viral,
I want to know why Jay C can diss the bible and go viral,
I want to know, why poetry starting sound like street preaching,
Yet nobody teaching these seeds to stay off the streets
I want to know why children keep dying in these streets,
Only a few know what I mean, only a few have real dreams,
Most living in nightmares, is that the reason no one really cares,

I want to know, why artist today writing the freakiest shit just get on the scene,
Damn I want to know a lot, I thought the older I got I'd have fewer questions,
Find out the older I got, the less answers I really got, damn that's saying a lot
Like why so many cops get to take black life,
No time away from wife, I guess that just life,
They say black life matter, seen like it only to the single black mother,
Whose about to found out her world about to be shattered,
Blood scattered another black life taken like it didn't matter,
Her son life taken by a cop, the shooter won't get any time?
Damn I want to know why,
So much on my mind feel like I'm running outta time,
Damn, where my state of mind, I don't want to be this awake,
Damn all I wanted to do was find my love of poetry again,
I mean, I just want to write something with meaning,
I want to write something without tears pouring outta my eyes,

Damn why life gotta be so hard to live,
Why did Miss Lady lose her baby, baby girl was only her for a minute,
Heaven requested her home, I guess it's a mystery that will always be a mystery,
Damn at least I tried to tell her story,
I tried to take her with me throughout this poetry
Rest in poetry, She'll live forever throughout this poem with me,
Only a few know what I mean, this poetry always been a curse and gift, for me,
Damn I know I'm supposed to uplift, I know I'm supposed to inspire,
I'm also supposed to document, cuzz this poetry is heaven sent,
It's a testimony for the unspoken, damn why I'm so awoken,
So many walking around with eyes open but mind closed,
Forgive them for they know not what they do,
They're just waiting for the lord to call them home
Damn I think I found my love for poetry again,
Poetic knight

I haven't wrote for you in while,

I know I fell off, and I haven't wrote for you in while,
I've busy chasing a dream, I know I'm suppose take a moment to breath,
And you said you wouldn't put nothing on me that I couldn't handle,
and there's been times, I've been wanting to turn into myself,
The other day, I felt like I was floating,
Wondering was that you,
Even in my dream I've visited the Raven,
Still he's shaking head saying go home you're not done,
So turned around and started running as fast I could,
Into the darkness of my mind, when I finally came to some light,
Something wasn't right, my hands were paws
I'm looking at myself and knew I was still in the dream,
I started running again, only to look up,
I couldn't believe it, the dragon flying by I gave chase and I don't know why?
With two thrust of his wings, he was gone so I thought so,

Then all of sudden, he was coming right at me,
I absorb him impact, as I was thrown back,
Looking up at the stars, I see the Aramaic cross
I know I'm not in this dream anymore,
This is so much more,
I can feel the snake biting into my soul,
I'm screaming I CAN'T TAKE THIS ANYMORE,
MAKE IT STOP, MAKE IT STOP, AND MAKE IT STOP!
As I clear the tears from eyes, I finally look over
I see the snake gone, but I feel battle within myself
I get up, I start running, and I'm running,
This time nothing going to stop me, I'm getting outta this place in my mind,
I was moving these paws as fast as they would take me,
I could feel the heat of the dragon,
As I approached obstacle after obstacle,
My senses were getting stronger and stronger,
I could feel the movement of the world that I appeared to be in,
I didn't know if I was still dreaming or was this real,
I kept telling myself, this is a dream,
But the more I tried to control this dream,

The more I tried to rationalize, the more outta control this situation became,
The words started coming outta nowhere, into my head as I ran,
The Scorpion will betray you, the Scorpion will betray you,
I started sliding outta control, I had out ran the land that seemed endless,
I finally come to a stop, in front of all things a mirror... I'm looking into this mirror, and what I see is too unreal,
I didn't want to believe, what I was looking at,
I turned the other way, there's a mirror there as well, I was being forced to dealt with right in front of me, Myself!!!!!!!!!!!!!!!!!!!!!!!!!! The things I tell him

Heart token,

Once a beautiful Soul,
Now never sensitive,
Now hard as a rock.
You've had a rough life,
No room for sensitivity.
The emotions so controlled,
Caption this,
Happy & Blessed,
But in reality,
Miserable & stressed!!!!
Never would you've believed,
Your life would have turned like this,
Only your eyes tells the lies,
Your body hides,
Heart been broken by the same man
Time and time again,
You even put up with his side chick,
While you cried at night,
Cuzz he's giving his dick outright,
These were the times I know you wanted to take your life,
I questioned why you stayed by his side, all this time,
I guess you're loyal till the end,

True to your commitment.
Too your own ignorance,
There is no end,
Your heart should be treated better than a token,
Your eyes should never be swollen from crying,
Your mind should never be stress out,
Your love should never be hurting,
You're so deserving,
For every one of my female friends that's just been through too much in life,
Cuzz really this started out with thinking about one friend, but somewhere between the start and the end, I put every woman that's hit me up with the bullshit, in life......
This even goes out to all but one of my baby's mama's, cuzz I ain't no damn Saint.

DAMN, this is a fucked up reality to admit......

Your mine and no one else's
Till the moment I tell the next chick the same shit,
She said, I got problems, I hold on to my ex's
Don't know how to let them go,
To most this behavior often misunderstood,
It's the fact that I got abandonment issues,
Stems from moving from foster home to foster home,

In my mind I've never really had a home
Till the moment I got my own,
And the fact of the matter no woman really shown loyalty,
DAMN, this is a fucked up reality to admit......
Yeah I got issues, situations change relations,
Then the pattern changes, changing women, like changing the radio stations
Maybe I'm selfish, maybe I can't be loved, maybe?
My heart doesn't want to be alone, my mind got game so I stay alone,
Haven't made love, what is that really anymore???
I love a lot of women, I mean I love A LOT of women,
But my soul begs to be in love,
Maybe in this moment of moment's maybe I just need a hug.....
DAMN, this is a fucked up reality to admit......
She said, I only call her when I need her,
That I never call when I want her,
I desire so many that I get confused on who I'm calling on,
I sat there listening, half ass smiling, half ass sad,
Cuzz she was breaking me down, to what she's come to know me as,

In her mind I was a first class ass, in her heart I was the best she ever had.
Still the fact of the matter she still packed her mental bags,
Then laid in the bed for the last time we would ever have,
Good Bye sex, the best sex we've ever had,
DAMN, that's a fucked up reality to admit......
Heather's seems like she's outta the door with this one, We'll see..
like a Sudden Thought

The prefect lips,

A caramel love skin tone, a love Jones that's got my soul on the moan,
I want to bring you home, make love under the cool Cali moonlight, let my tongue take a sexual exploration, I ain't going to lie, baby I want to get in between yo thighs, pull yo panties down, taste yo sweet temptations, read my words, let yo hand be my hands,, this night,,,, whatever you do tonight! Make sure you squirt and think of me!
Even the prude wanna push the like.....
But she won't cuzz she'd be admitting too much,
Every woman needs to be touched.....
I think went to soft with ^^ that statement,
What I meant was, every woman wants to be fucked!
It's poetry, or is it more about knowing what every woman needs?
I'ma take my time,
Cuzz tonight I'm teaching and preaching,
Given lessons and blessings,
Yes I said given blessings,
Here what I mean,
I want you to take some time,
I want you understand the frame of mind!
Cuzz when a real man puts it on woman,

I mean so good so hood so real, with skills, ladies that can't be nothing but a blessing,
Loving it and confessing it is all you can do with it!

And how do I know ladies, cuzz you ladies have told me to many times how well, Johnny really is!
What y'all didn't think I was gonna get in my ego!

When I don't trust you,

It's not cuzz I don't know you,
It's cuzz I know you,
Know where you've been
What you've done,
And who you've wronged,
The way your eyes tells lies,
The way the sounds escapes your lips.
The way your body moves and trips
It's the way the birds fly away when you're around,
It's the tremble of your voice,
It's like all the choices you've ever made been iced away,
I don't trust you, you don't understand where you stand as a man,
It's like you're lost in this land,
Looking in your eyes, it's like looking in the windows of a lost soul,
Poetry dies, words cry, nothing matter to you in life,
You're in that place of depression,

Scatter thoughts, heart broken, smoking soul, damn alone,
I don't trust you,

How do I know so much about you?
I've been you, and I'ma pray for you,
Keep your head up, I might not trust what you'll
do, know that someone loves you...

Over the years,

Over the years, I've been making love to you with these words,
Even when the words were about other women,
You've owned them, stole the emotions for yourself,
How many times have I made love to you?
How many times have my intangible touch,
Left impressions on your heart and soul
How many times have you wrapped yourself up in my passion?
The passion of my words, ending your night with the thought of you and me
They're going to be people reading this post,
Some are going to take it as if I were simply writing a poem,
While other going to take as I might be talking to someone
While other are going to take as if I'm in my ego,
But you know when the words become so deep,
The description gives the depiction of our situation,
Making love till you can handle this anymore,
I am temptation, I am an alluring illusion of desires,

My I love You's, my truth,
Becomes the passwords to the lock you placed upon your heart,
My poetry hidden spells, that you recite after reading three or four times,
No other poet, no other writer, no other spells are stronger
Your mine, now and forever, there's no escape,
In your mind, I'm pasted present and future!!!!!
You've been reading for years, tell me, and tell me you love me!
You'll know when the words are for you,
Cuzz they'll be only words I've spoken to only you!

Close my eyes,

To open my heart, there you are!
So many women have been in my heart, none ever made it home,
Looking inside myself, and realizing how you've redesigned my life,
I can't believe you've chosen to walk this journey of my life........
A woman that could have any man she wanted,
Knowing all my sins still wanna be more than friends,
I ain't never had a friend like you, moment to moment I'm falling in love with you,
Baby this my truth, I wanna be with you, right or wrong,
Close my eyes, to open my heart, there you are!
Oh damn, baby, I know things ain't been right been right between us,
I know we've missed making love
Let me say things to you that I've been neglecting to say to you!
I realize how much I love you,
Damn I feel ashamed, cuzz I've been holding these words in,
I admit I was wrong,
Baby I hope you reading the words to this song,

Even doe I haven't spoken to you, you haven't spoken with me
I gotta know if my love is good loving to you,
So I know to keep doing what I'm doing,
Or let me know if I need to change up,
I wanna do all I need to do to pleasure you,
I love you, I wanna keep you, be with you now and forever
Baby you're beautiful and I'm full of good loving,
I just wanna keep a smile on your face, take you to different places,
Cuzz when I close my eyes, and open my heart, there you are!

Trade places with her,

I mean, I need you take her place in my heart,
You see, I'm not feeling her like I'm feeling you,
Now I this might sounds wrong,
But this has been coming for some time,
I've given you, myself emotionally,
Emotionally cheating, damn baby,
Wasn't my intentions, just kind of happen?
I started giving you all our problems,
You started to help solves 'em,
Suggestions dinner and dancing
Big daddy Johnny's winning,
Really losing, cuzz in that moment I started choosing
The last night I slept with her,
I had you on my mind,
I was making love to you on top of her,
I normally have my eyes open while sexing,
Not this time, not this time, reason why,
I trying to enjoy the pleasure and hiding the guilt at the same time,
Damn she's my Baby, wanting you to my Lady,
I know I know shit sounds crazy,
Now posting this poem on Facebook,
Gonna sound even crazier,

It ain't a good look,
Gotta tell you what's been going in my mind....
Baby I wanting you, in nothing but a T-shirt,
I need help with this vision of sin,
Miss Lady a request for us to get it in,
I'ma need you to take her place,
Baby meet me at my place,

Will you marry me

I want you to trust me, yet and still we both have a few issues,
If we talk a few things out I think we can make,
Take this to the next level, step 1, let's set up a date,
Meet some place we can set back and relaxes talk what's fact,
What fiction, what'll define the both of us, love and trust we got that,
Step 2, I'll show you how I'm making a transition from single and mingling
To commitment, I know you've already started to show how much I mean to you,
You kind of let it slips the night we were in the middle of it,
I want to show you that I can take care of those words of yours,
I want to be yours now and forever more, I make this promise to you,
I'll protect your heart, I want to have foundation in my life,
I want you as my best friend, I want you as the one I get into it with,

I want you as the one that I'll apologies to you when I get to acting like a fool,
I simply want to love you now and forever more, step 3, I want our honeymoon not be a one night event, I want our honeymoon be what we do for the rest of our lives,
I want you take this ring, cuzz you to me, means everything, all I'm asking is will you marry me?

WHAT HAPPEN TO THE DAMN VIDEO?

Unbelievable,
I'm there with you,
Are you here with me?
My question may seem strange
After my statement,
Yet I have to ask,
I'm trying to show you my vision
And yet you see my vision
I see you're putting your own spin on it
I'm trying my best to hold your hand as we walk,
Insecurities will hold us back.
I keep telling you this is making us, stagnant,
I tell you, my net worth is only as strong as my network
I tell you, trust me, then you turn around and do petty things,
You say, I don't want to always be in this place,
Yet you find ways to stop our growth,
I got one more question,
WHAT HAPPEN TO THE DAMN VIDEO?

Passions getting tired of ya boy Johnny Playing games, and Heather love on a feather she ain't feeling no better, still I'm able to hold to both treasures, like a sudden thought.

Lovers Rant!

I can't remember the last time we touched,
Damn I miss you so much,
Am I lusting, craving, you or desiring?
Whatever it is, I'ma need you to cure my longing,
My pen bleeds the blues of missing you,
I should made more time for you,
I should have did the things to make you my wife,
Baby oh baby please walk through these door,
I need you once more, I'm love sick and you're my cure,
ya'd ya'd yea'd yeah,
I want you to know you're the inspiration for my words,
I want you to know you're the foundation for the love I have for you,
I know you know that ever since you've been gone,
I've been misbehaving, living insane, speaking crazy,
Loving on lazy Ladies of sins, calling them friends,
I got no excuse, for the reason of getting it in,
It starts with in boxes, on Facebook,
Then a meets and greets, that lead to getting drunk and fucking,
I know that ain't that ain't that ain't a good look,

But it's better than adding some shameless hook,
Now I'm here requesting your forgiveness,
I never knew what I had in you till the moment I lost you,
Baby I never cheated on you, that's my truth,
I don't give a damn what anyone has to say,
Baby I still love you, seem like I'm dying without you,
Be my breath of fresh air, I'm trying to show you I still care,
Just come back to me, HEAVEN FULL OF ANGELS,
I need you because you've always been my heart and soul,
And now that you're gone, I'm trying really hard to move on.....
I just don't know to what?
Rest in Peace, I'll always love you,
Yes this is about Heather, but she's not dead so to speak, just dead talking to ya' boy Johnny Frost

What won't matter, is the arguing.

What won't matter, the creative differences
What matters is that I have my sissy in my life,
The late night in boxes talking about poetry,
The crazy things we both see,
Between you and me, we've had a million laugh in our short time,
I wouldn't trade our friendship for nothing in the world
What won't matter the distance between you and me?
Cuzz I keep you close in my heart,
It's been that way from the start,
And the other night when I got off the your show,
It wasn't cuzz I was tried,
It's cuzz I was tired of hearing all the thirsty poetry,
I knew I had get off the line before I got on and went off,
And it does matter,
What matters between you and I, think the guy you need in your life,
Is in your life, that's not between you and I,

And it doesn't matter

*And it doesn't matter,
I need you to hear me, I need you to read me,
Cuzz truly I love you sissy, and I gotta tell you I'm sorry
I gotta say I tried to make this right, Make this right between you and me,
Cuzz all that matters to me, that I have you in my life,
Like a sudden thought,*

My light bright,

My life, it doesn't get better than you,
Having you by my side in this life,
Days when I'm sick, you come to check on me, to make things right,
You said I'll never be alone again in this life,
Finally feeling the words that I've been desiring all my life,
My light bright, my sweet heart in life,
Have I finally found someone to struggle and cuddle with?
There's happiness in our love nest,
Even when we argue it's more of negotiations for late-night relations
All that I ask is you stay patient with me baby,
Just know there's no more comparison, I'm in love with your passion,
May this love be everlasting, you came into my life like a sudden thought,
Now you're in my life, like my final thought, day and night,
Damn how deep can I get into this write?
I want you to be my wife,
You're my light bright, you're my truth, your my woman,

I want you to be my wife,
Loving you mind body and soul, I release and let go,
You've become a better part of my soul,
You've pick the lock on my heart,
And from the very start I've thought you were someone special
There's a mystery to our story, and I know people are like
Where did you come from? How did you get here?
I'm like where have you been all my life,
You're my light bright, loving you now and never letting you,
Just letting you know,

Poetic Knight, in my zone

There a zone I haven't been in for a long time, I can't go back that,
 Push forward, push forward push forward,
This year been amazing, I got to admit it,
Man doe, I got to keep it so real,
I lost so many that was riding I gain so many that's riding
It's love and it's lesson that got me stressing,
There are days I see the vision so clearly,
Then other days everything become blurry
Recently I got the chance to work with 12 of the most amazing,
The fast and furry 13 started working,
I mean surly what we've created is truly amazing,
I could have never done this back to back like this,
Never alone, never on my own,
Thought of a Saint and Sinner, now speaking to the next G,
Man we should be celebrating, but its bitter sweet,
Cuzz in my heart of hearts I'm hurting,
She should be here, she should be here,
As liquid prayers fall from my eyes,
Lord knows she should be here,

I gotta do this, like I do with anyone that's walk away,
It's the only way I can push forward, Last prayer,
Lord I got to stand strong, cuzz so many depending,
Lord she walked outta my life, take her outta soul,
I don't want to feel this pain no more,
I need to focus, you've sent your wisdom,
It's time to move on,

It's never about the money it's always about the message,

15 likes a day made my day,

Baby steps to get my life right
Tonight I let lose the thoughts of the sinner,
There were nights I would stand out on the corner selling rocks non stop
Till I found one to stand one the corner sell too her ass, I know low class,
The game wasn't what I thought I would ever be,
And when I went to prison for all my sins
Man I thought I would give in,
Turn to the only one that could change the thoughts of my soul,
I had to find a way to get back right,
When I came home, family and friend would "say not you"!
So many had no clue what I was living through
I disappointed some; others just let me go altogether
Cuzz so many knew
I knew better,
However I was doing what I had to do!
 So true so true,

Baby steps to get my life right
Baby steps to get my life right

Baby steps to get my life right
Now I rather use my words to reach the hearts of lost lovers
Let the good in me shine through,
I know reality sells better than sex alone,
When I first started this, it wasn't about the poetry,
Somehow someway, it came to sharing every thought, every moment of my life.
Somehow someway, it stop being about the poetry,
The attention from so many different women becoming my only attention,
15 likes a day made my day,
All these addictions,
Just add to my long list of sin,
The chase of money,
The chase of attention,
The chase of sex,
The chase of poetry,
Man this just the short story,
Is this what I want the world to know of me?
Man fucks the world,
Is this what I want my daughters to know of me?
Lord I hope you go a better plan for my Destiny,
Cuzz everything as of late seem like a mystery

This journey been rough, tough and at times it's been too much,
But I ain't gonna lied there's been good times,
Cuzz you've given your child a good state of mind.
Baby steps to get my life right
Baby steps to get my life right
Baby steps to get my life right,
Ok this my last write tonight!!

So Much Pain

Got to the point that had so much pain in life,
Called a friend the other day, cuzz I need someone to talk too,
The convo took a crazy curve,
Cuzz there was still too much between us, you know unspoken love,
Damn I felt so empty, but I ain't looking for sympathy, or anyone pity,
When I get to feeling shifty, I just get on these knee and pray for better days,
But these days seem to be, hurting more and more,
I know I got scores to settle, to keep this castle, I'ma have to battle life's battles.
So if it seem like I'm hard to reach these days,
Just know I'm doing me, focusing on me,
And I know I got haters playing games with me,
I watch read as much as I post, I've seen what nigga do,
Trust me I got copyrights for everything I do,
So why these fake mudfucka write, trying to do what I do,
Pay attention when I get to suing you, when I'm through with you,
I may not have to write another night,
Yeah I maybe a character to you,

But I'ma character that I'ma use,
Cuzz this is my life, I got rights,
Putting out a book is sumthin I gotta do,
Trust me it's almost through,
These stories are mine and taken outta the journey of my life!

Confession 2

I'ma thief,
I gotta admit it,
Where do I start?
I'd done stole so many women hearts,
Done tore so many women hearts apart,
Told so many lies,
Can't track them down with a hunting hound,
So when I get down, ain't none of them around,
Done stole dreams, and offered wedding rings,
Saying the three words without meaning,
The change up,
Done prayed for the prefect woman,
Got the blessing than run away,
Cuzz I feel safest when I'm playing these games,
Damn that's a sad thing to say,
This last lady ain't gonna let me do her this way,
Cuzz I gotta friend in her, (that's strange?)
So even when I'm hiding,
She ain't gotta problem in coming to find me...
Even when my words ain't rhyming,
I gotta say Lord, she's prefect timing.......
She's one of the most beautiful people I've ever met in my life,
Got me wanting to change my ways,
I see happy days coming our way,
The change up, and it feels good...

Its starts out as a date,

I mean its starts out real late,
She call me over to her place,
Dinner she made,
Fried chicken,
Cornbread, mac and cheese,
Yeah nice dinner plate,
Start the movie before it gets too late,
Love Jones,
Yeah, cuzz at this point all I want to do is jump her bones,
But I'ma play cool,
Watch and understand these moves,
She lays her head on my chest,
Jill Scott playing in the back room,
It's a lot going on, with a lot of clothes on,
Kissing, and touching,
Whispers????
Biting, more touching,
A little tickling, more kissing,
Sucking, and rubbing,
Licking, more biting,
Unzipping, that's when she dropped the bomb,
We can't, her little friend here,
Johnny: Wait' I'll be back baby,

Her: Ok,
I walked out to the car and came back with something I picked up from Walmart,
Walked back into the room showed her the towels and condoms, and said not a problem, let's get it in.

Been thinking about my children,

All day, damn
Feel so alone right now,
I'd seen the cushion of my youngest child,
I see my baby girl's smile in her face,
Damn,
What am I working for what?
It's seem like I'm living a buried life,
These rants, these vents
Going nuts, Insane, lost in my own brain
Haven't eaten all days,
Seem like I don't wanna do a damn thing these days.
Still living afraid,
Missing so many people in life,
Damn got this feeling of depression coming my way
Really don't gotta reason to chase it way,
My world, really ain't shit without the smiles of my babies girls,
Damn, lost in my own mind..... Still hurting,
Feeling down, starting feel like nothing really matters now!
Just wanna fade away,
I wanna believe I'ma man,

It really doesn't matter,
Wanna buy drink,
But fuck it,
I really don't need be drunk to think,
It'll just add to the tears, that's already in the bucket
Let me speak the drunk mind, with a sober state of mind,
I've been pushing my girl way for weeks,
But she really care for me,
How do I know?
Cuzz she keep coming back to me,
I don't see what she's see in a nothing ass nigga like me...
I look the mirror only to see nothing,
Yeah now I'm hurting,
Tears pour from my eyes,
When I finally realized my life been a real lie,
I just want to hold all my children one more time before I die,
 One,

I know I won't see for the rest of my life,
Still Trying to swallowing that pill,
I miss Kay baby,
Her mother's found her a better father,
Baby girl Janelle won't understand why I can't just come get her in life,

*Devon, might not be mine, but he mine,
Amaya Amaya,,,,,,, You gotta know I'm thinking about you every day...
Carrie,, Baby Daddy's Love you,,,,
I'm praying each of you will do,
What I did when I needed to know my Dad,
This life ain't fair,
It's fucked up at best,
I'ma keep filing papers for each of you,
I'ma keep looking for each of you,
I'ma keep looking for each of you,
I'ma always love you,
Missing so many parts of me, without all of you....*

"When the words"

I love you" don't mean a thing,
When the words "I love you" don't mean a thing,
Words wrapped around emotions of lust...
Nothing much just a sinful touch.
Bring the blessing of an offspring...
Heated situation the loss of what could have been...
Make love till tears fall...
Sinful night brings child into life...
A mother wishes a father to hell...
A father wish a mother well...
Their love was a secrets only the streets would tell...
This when the words "I love you" don't mean a thing.

Saying goodbye,

Dealing with finale tears in eyes,
Cherish the people you have in your life,
Cuzz one minute you can have them, the next their gone,
Nothing in this life, no one in this life is promised,
The wife kisses her husband early morning,
Car crash on the way to work he's gone,
That night she's on knees asking the Lord why?
The sister that love her brother so much,
Drug overdose and he's gone,
She's on her Knees screaming LORD PLEASE!
The home girl, that's married the wrong man,
Beaten to death, she's gone,
The Homies, in the streets with candle light visuals,
It ain't got to be a senseless act of violence,
When it's time to be called home,
We'll all walk that path to the crossroad home

Breast cancer can be death's answer,
When it's time to be called home,
It's time to go,
It's time to go,
Ain't got to be a senseless act of violence

Life too short to be holding grudges

Damn it sounds like a movie, or helleva written story!
I mean damn, my concept might not get million and one likes,
I'm just trying to send my message through this write,
I mean this is everyday life, in this write, right?

Beyond disease
Beyond disease

Cherish the people you have in your life,

Hereafter,

Love and laughter doesn't matter,
It's said a picture is worth a thousand words,
With all the art, comes tears and broken hearts,
Damn where I start, trapped in my own word,
That world falling apart, the question shouldn't be where I start,
Where does it end, where does the sin end,
Every part of my heart tell me, I should have never started,
Hereafter, love and laughter doesn't matter,
Ratter tap tap, Damn this how I'll get passed her,
I gotta maintain, can't fall into a depression,
I got people that believe in me, that's waiting on me,
The grind gotta be the better state of mine,
Hereafter I ain't time for love and laughter,
I gotta put these chapter together, damn that's how I'll get passed her,
Love on a feather, let that shit fly away,
No need to pray for better days,
Bitch I ain't that nigga, you going to play games with,
Lies to my face, place to place, argues over nothing,

*To hide what you wanna do, I ain't that nigga you gotta lie too,
I ain't that nigga that's going to beat you, I'ma let you do you,
Bitch you been, knowing this shit, I ain't never been that nigga,
You're a good woman, what's good about you,
That wasn't good about the next or even an ex's
Oh yeah just sex,
Bitch I ain't that nigga, that's gonna stress over not having sex.
Cuzz what you won't do, the next will do,
Never should opened up to you, I should keep my distances,
Yet and still I try my best not to be that nigga,
How many ways I gotta say this, yeah that shit I did the other day
Way uncalled for, but your next move colder than snow case,
Mine was memory, your shit present day, bullshit,
Fool me once, shame on me, fool twice. That's on my life,
Never fuck with you again in life, bitch I ain't that nigga,
Damn, why am I going to so hard?
Damn fighting wars with a woman I really want,
Don't know how to even the score,*

After this post I might not hear from her anymore,
Questioning everything emotions running wild,
Thoughts all over the place, questioning do I really love her,
She was my love and laughter, only a few days ago,
Now I gotta find a way to let her go,
She's moved passed me, partying from the moment we broke up,
Was I her future or her rebound cuzz she apart the club life now,
Not my scene now, been there done that, not a part of my life now,
Changing faces getting distance, changing places hearts falling apart,
I ain't that nigga anymore, I've seen myself grow,
In a different place in my life, and the truth of the matter I wanna wife,
Damn I might not make that accomplishment,
Too many broken hearts on my part, and karma don't play that shit,
Just another lost nigga with no more attempt at love,
Just another poetic thug that needs a hug,
Only few know what I mean, doesn't matter cuzz nobody reads....

I know you see what going,

My girl I and ain't going strong,
Why you trying to take advantage my emotions,
Texts on the late, just to see if I'm ok,
I'm seeing the games you playing,
If I fuck with you I'd be doing wrong,
On the net, writing sad songs,
Cuzz if my girl find out, on the real, she really gone,
 Now why you want to creep and sneak,
Sending pussy shots, talking about here's a peek
Girl I'm just not that weak,
We aren't even been broke up for a week.
What do you really think?
I'm too old of a cat to be playing these kitten games,
Girl you must be going insane,
Please let's not play these kind of games,
These kind of games, these kind of games,

And even if we don't get back together
Love on feather,
I got to do what's right within myself to keep my shit together,
It's going to take some time,
Making sure all emotional doors stay closed,

If you check my recorded I've never went back to an ex,
Unless I claim them on my taxes,
While wearing red and white glasses,
We'll still friends, it's just not our time to get it in,

Like a Sudden thought,

It's time, time to let me go

It's time, time to let me go, you need to move on with your life,
We've made our mistakes, forgiven each other,
Now you have someone in your life that wants you theirs,
How do I know, no man will allow a woman he doesn't trust around his children?
No man would leave a woman he doesn't love, alone with his children
How do I know, you've been going back and forth with this man for two years?
Every time you leave me, you give a little more of yourself to him,
I've been a distraction in life for far too long,
How do I know, you stopped saying I love you, over a year ago,
It's time to move on,
I'll always be your friend, I'll always have a love for you,
Let our ashes to the sky, be our last goodbye,
With tears, in my eyes, I'm telling you, this is your time to fly!

Be happy, let that man love you, allow yourself to be loved....

You've found what you were looking for, trust in that love,
From the bottom of my heart I wish you all the best!

Poetic Knight......
There are some rules a man should always follow,
Some rules should never be broken,

Never date a woman you work with,
Never make love to a woman you work with,
Never break the woman's heart you work with,

Some rules should never be broken,

Never take a woman serous that only pays attention words never actions,
Never date the woman who thinks like a man, and acts like a woman,
Never make love to the woman who thinks like a man,
She doesn't know the beauty of her true essence,
She's hurting and she's not a blessing, you'll find she's always stressing,

Some rules should never be broken, No matter how good the sex is!
Heather became my lover when I was good will hunting shopping for beautiful gifts in thrift stores!

Take my hand please

Take my hand please, I need someone to talk too,
I'm going through something, I don't need you to fix anything,
I just need you to listen, as of late I've been suffering mentally,
Invading thoughts of failure has enter my thought process,
I've cleared my personal space of certain people,
Rather I did this consciously or subconsciously it's done...
Creatively and poetically, I've been censoring myself,
Reading my only words I've become ashamed of my own writing,
There's no one to blame, I started craving attention,
I've become addicted to delusions of grandeur,
As if anything I wrote or created would have been magnificence
There's a difference between being confident and arrogant!
I forgot the basic forum of my own writing,
I started being lazy in my own wordplay,
I took on a style of writing and got trapped in it,

My flow became stagnate, I lost myself,
The reality anytime a woman enter my life,
I start making changes to my life, when the relationship fails,
I'm left empty, shattered pieces of my mental left all over the place
Just when I get a chance to collect all the pieces,
I allow someone else in, love destroy my poetry,
The cycle, erotica writing, and then sensual writing, last but not least,
Something goes wrong the honeymoons over the friendship found to be unreal,
I start reminiscing about times with other women,
My writing become a chess game,
For attracting the replacement of the woman I'm no longer interested in,
I start ripping apart the foundations of the friendships,
The truth of the matter I start losing trust, and love,
I've never broken up with a woman in my life,
That's the truth, more of the truth, I do start mental relationship with other women,
I'm good for that one, I may never have intentions on sleeping with the other woman
She becomes the friend I turn to for mental companionship,

Something I've learned from all my play sisters,
Eventually the woman become a play sister,
Around this time I noticed my poetry come back to life,
The day I truly fall in love, I'll never write another poem again,
John Frost
Only a real woman gonna last,
All them other women here today gone tomorrow,
Love me now, and I'll surly stay around,
I see a good woman, the truth of the matter I see many of them,
Mama I'ma need you do a little studying,
Read the words cuzz truly words deep
Then reread all the shit I don't say,
These be my hidden truths in my spoken lies,
I'ma ask you to tell me you love soon,
Reason, I need to know when it's fake to know the difference when it's real,
Yes Mama I play chess,
But ain't the best, But I'ma put this love to the test,
Cuzz I don't wanna live with a woman with a whole a lot of stress
Yeah Mama, I think you may be able to pass my test,

*Cuzz I see you more than just a chance at sex,
And yeah mama I can afford the latex,
Kind of need to know you offering up more than sex,
Cuzz any woman with a hole, can offer that up doe....
Next level,
Don't have to many ain't got,
Cuzz real talk I'm offer up a lot,
My love my passions provisions
Mama I got ambitions, determinations
I want a house out in Malibu something I share with you,
Some of these Nigga's ain't got a clue,
I got a vision on what I wanna do for you,
Mama this is my truth,
Mama you ain't got to worry about my Babies Mama,
Cuzz I don't have none, my children have real mothers,
The law ain't got to tell how to raise my seeds
I've been do my thing since 23,
So really you ain't gotta worry about a damn thing,
Mama, I think we could be a winning team you and I,
Only a real woman gonna last,*

All them other women here today gone tomorrow,
Now you know better let's do better together, fore
I've been really quite on Talk shoe and blog talk shows,
I figured, I could take a step back I won't be missed,
Been working on private projects, trying my best to stay positive,
Working on my family, doing things right,
Trying my best to stay outta the way,
Funny how negative shit always get back

We went from friends to lover a back to friends;

I find myself thinking maybe I messed up,
Maybe we didn't try hard enough,
Then I remember how we were when we first started,
The up all nights talking on the phone laughing till the moon gone,
Silly laughing to songs, nothing between us was wrong,
The moment we started changing, gaining feeling, sexing, lusting and loving, everything went wrong, the trust went out the door....
Tonight we went back to what's right, you became my best friend again, we are better friend than lovers, but our under the cover loving, was a great discovery, hmm interesting!
Fuck it, it's time to get downright nasty, ^^^ soft shit^^^
I miss hitting in Palm Springs, making the rooms around us tell management,, the sounds too loud,, women walking passed us smiling,, You screaming, yelling Johnny, oh Daddy free this pussy,,
It's yours.

Ontario sexing even more, till that pussy got sore yet you still begged for more, so what's next? Las Vegas, I think yes, I'ma keep that pussy wet, Second thoughts, ^^^^^ that might be too freaky^^^
Should we mix this friendship up with sex?
Should we even try again?
When the next time things go wrong will we still be friends?
Can we handle the fact that we both been sleeping with other pal's?
I mean I got a Sometime lover and you got the Random Cat, who loves hitting that?
The third thought that come to mind, ^^^ too much truth^^^
I'ma have my Cake, eat yours and her pussy too!
All that belongs to me, your heart and body, her heart and body,
And the Random Cat, he ain't nobody....
Ego trip^^^^^, I'd be a fucking fool to think I could get away with that..... (Or would I)

I enjoyed talking to you tonight.... All smiles

I'm unseen, unheard, I'm alone,

Felt no love, hurting,
Soon I'll be in my poetic zone,
I wanna hurt someone,
Doesn't really matter who,
Just as long as I know someone else is hurting too!
I want someone to feel this pain that I seem to be going through,
No that's not what I really want,
I wanna see someone hurt more than me,
I wanna see someone bleed, and scream in pain,
I want to hurt someone so bad that they scream the Lords name....
Cuzz that's how much pain I'm in.
Know this

Remember this, I'm an unknown artist,
That's calling his own shots,
And you never know what the unknown will do!
Know this,
I'ma engrave this situation in pages,
And know I lied when I said I don't lesson to archives,
That shit you spite gave me hive, I mean that shit was live,
I mean you're mean on the mic,

*There was a time I had nothing but respect for you,
I've told y'all about shooting subliminal,
Know this,
The moment you spite that shit,
Page poets spend too many nights writing bullshit just to get like,
Warriors of the night, Poets with no life,
I tried not to take that shit personal
Then I heard the next line,
Poetic nights, poetic writes, Naw nigga that shit ain't tight...
I was like I know this nigga ain't kissin, cuzz that's my line,
So I listened to that shit twice,
Poetic night with emphasis on the word Knight, Alright
Know this shit, Unknown King, saying anything,
Boasting the beats, never ran the streets who to speak on anything I'm doing
Fuck you and your crew, preaching, teaching nothing,
Nigga I'm the first to get on some responsive shit,
Then be on Facebook requesting your bitch,
Writing poetry have the hoe liking the shit,
Then get in her in box, "baby you know I was thinking about you"*

*Nigga I got pictures of the hoe too! Nigga maybe I'll post the shit,
Wait let me stop, that diss might not have been about me, all subliminal!
If it was he'll respond to this post, I figure!
Poetic King....*

Let me make love to you

Like this was the our first time
Let me touched you.
Let it be the ride of your life...
Let me cum inside staying strong for even longer ride.
Hold my hands so I know how intense it gets for you...
As I watch the sweat fall from your face to your breast...
Your body could never lie....
You enjoy our moments...
I know when you cum each time...
Your sexual milk creams as you move your hips....
This how we make love each time like it's our first time....

Heather suddenly

There's some emotion
Setting myself up for heart break,
Loving at the distance, believing there something someone out there
Who cares who'll be there, talking about Heather again?
We were friends getting it in, when we were together,
She was that forbidden love, that hidden love, I was stuck her like a drug,
Heather she was more for pleasure, however I was addicted to her,
Been in recovery still and yet I find myself, trying to discover myself,
Can't help but look back at my memories, you know they tell our love stories
Find myself hurting watching how the beauty of us became love
Feeling fucked up, lost without love, damn I need that hit one more time,
Thinking about Heather I need a better state of mind,
As of late I've been on a grind, trying to keep her off my mind,

Got this desire to fuck one more time, and really it's a mystery to me,
Well not really, we just got to so much history,
And maybe that's the reason I'm hurting,
Late night bleeding, insomniacs so all my night dreams are wide awake,
Trying to figure out how to untie my side of the soul-tie,
These words really have tears in my eyes as I type this late night,
Liquid prayers escape as I pray, questioning everything,
Trying hard focus on the screen as I type, cuzz I know Heather long gone,
Two year ago we meet, just a year ago we were deep in love, a year later,
I don't know Heather anymore, what else can I say?

In my heart of hearts I'm happy for Heather, She found her classic man,
All I ever wanted was to be a gentleman for her, but in my heart of hearts I was never good enough for her, and I knew it!

How did I lose Heather?

*For all the reasons you give me to say it's over,
All the reasons I give you to stay,
Not letting our season to be over,
Baby we are more than friends, I'm fighting to you,
I want to be your one and only lover
I don't want us to be over, please baby forgive me,
I know you caught me red handed
I let temptations get the best of me, baby please listen to me,
I won't say she didn't mean thing to me,
I don't want to you us as an excuse for my cheating,
Just please don't leave me, please listen, I ain't to proud to beg,
Just let me get some get back, to us back on track,
You know I love you, I'll never let happen again, baby please,
I'm trying to fix this, I'm trying to love you, and I'm trying make you see the truth in us!
I'm trying, I'm trying, and I'm trying, not to start crying, baby you know I ain't lying.
Just please forgive me, I'm your man begging for your forgiveness,*

You're right, I'm wrong, I'm this place with you, better or for worst,
All I want is for us to get through it together,
We agreed love each other now and forever,

I just some shit just can't be forgiven, you just gotta live with the sins.
How did I lose Heather?

The thought of you leaving,

The reasoning you're staying
Has me wondering,
I reach, you push,
You reach, then I push,
Both hurting, both crying, both feel like we're dying
So tired of the fighting,
You want to go, then go,
You want to make Facebook posts,
You want to tell the world,
I'm doing you so wrong,
You want to call your family,
Sing them the drama from our sad song,
Now we got an audience cheering us on,
You're so tired of my bullshit,
I'm so tired of this drama shit,
We're just not clicking,
But I'm not ready to quit,
Let's work this shit out,
Let's lay OUR PROBLEMS down,
Let's believe in the words me, LOVE YOOOOUU!
Let's not walk out, no not NOWWWWWWWWWWW

I wanna see your smile I want you NOWWW and FOREVER,
WORDS COULDN'T GET ANY BETTER!
BUT YOU WANNA LEAVE,
THAT'S ON YOU AND NOT ME
CUZZZ I'M STILL REACHING,
I'M STILL HERE WAITING, I'M STILL HERE BELIEVING! I'M HERE CONFESSING!

I simply believe it doesn't get any better than you and me,
We got problem but it's nothing we can't work out!

Let me do me,

Give me a second cuzz here it come,
let me get off that other bullshit,
Let me do me,
Can't let what others think of me change my creativity,,,
Let me speak with what I know good within myself,
I ain't Mr. West
I Know the Lords walks me doe,
Let my actions speak louder than my words could ever be,
Let nothing change what inspires,,,,
Really I'm living,
And if you got time to watch me live,
then talk shit about me,
Just lets me know I must be doing something interesting,
I can't let those not on my level, interrupt my flow,
But please do continue to speak upon me,
Like the Five Hearts Mentor said,
" learn to use everything,"
So I'ma write everything that comes my way,,,,,,
And don't give a damn what anybody gotta say,,

*maybe I'll write something someday,
That'll make all my haters just fade away,,,
Give me a second cuzz here it comes,
Don't need to justify someone else's lies,
If you can't see the truth in my eyes,
Then you ain't looking
I'm here like an open book,
Just take a look when you open your Facebook,
I'll be the first to say I ain't perfect,,,
I'm writing this to music,
So most that don't know how to flow
Gonna miss-understand this,,
I would give you a clue to who's
but that would good for some You's,
Yeah I'ma change my mood,
Cuzz really I'm a good dude,,,
And I really,, I do love some of you...
Just wanna say thanks to all those that I spoke with
About what's going,
thanks for not questioning on Facebook about things,
cuzz y'all know I would a just answered the questions and not cared who read what I was talking about,,,, and thanks for not pushing the like on this post, cuzz really that's a dead*

giveaway,,, I still got haters and spies on this page,, lmao.....
Just wanna say thanks again,
Thanks for giving me a second,

Tonight we should be together

Tonight we should be together, making love to that old record player,
And I know you tend to think I have many women, baby I'm not that kind of player,
I rather have you by my side, tonight, instead of writing poetry
Trying to incite your attentions, baby you see my intentions,
Let's make love, I'm addicted to you like a drug, baby come feel my love,
Come over, let's listen to that old record player,
I got Ron Isley serenading in the night, I got candles and rose with dinner tonight,
Let me love you now, let me make you feel special tonight
You're my woman, letting you know I can live without a few things in my life,
None these things includes you, Not one includes you,
baby let me love on you, listening to that old record player!
We should be in different homes, we should be holding each other,
Baby friend and lovers, lover and friends,
Come over, let's listen to that old record player,

*Come over, let's listen to that old record player,
I want you now, I want you now, I'm needing you now...
It should be you and I and that old record player*

Who's Heather love on a feather

Running been what you've been doing best,
Can't speak to me without bring up the past,
Heather love on a feather you know better,
You got every reason in the world why our love didn't last,
Funny thing about life,
You use the same reasons my darken beauty believes,
Yet blame me when I say y'all all the same,
All y'all played the same game, all get upset when I bring it up,
Time and distance, time and distance, come on that's the bullshit,
Whose Heather, love on a feather, girl you know better,
I ain't saying shit, cuzz you want to trip about bullshit, I can never fix,
I know why you didn't want to admit, about books getting sent,

These thoughts of Saint and Sinner, will have you reminiscing
The same reason none of the rest wanted to read the pasted love of we,

Words get deep, in my heart, this is the place where you once resided,
Who's Heather a mystery to all that reads?
Only the Socialites know about that life, don't worry doe, none will speak!
See how I get deep in my writes, you know my life, Who's Heather??
These words all come to me as a sudden thought

Beauty in the eyes of the beholder,

Allow me to tell you what I see,

She quite, yet her walk is loud,
She grabs attention the moment she enters a room,
Her presence places her in the hearts of every man,
She's desire and fire, she captivating and alluring.
Passion exudes from her,
She doesn't have to say a thing,
It's like her silence is being use as a weapon,
A weapon on the minds of men....
Who is she, where did she come from, and why is she here?
Poetic angel, or a mythical woman too good to be true.

Only a confident man will approach a woman with so much physical beauty,
None seem willing, none seem to have the knowledge of self-worth...

Remember beauty in the eyes of the beholder,

Hello, my name is Johnny Frost, and what's yours?

My name is Heather,

Johnny: that's a beautiful name, is there something I can help you with today?

Heather: No I'm fine,
Johnny: If you need anything Mz Heather, allow me to be of service, by the way you are a very beautiful woman. I could not resist in telling this, it's like you've stopped time the moment you came into the room, and if you don't believe me, take a second to look around, you have the world within this room attention...

She follows my instruction looking around and noticing that all eyes were on us...

Heather: oh I hadn't realized that everyone is looking at us...

Johnny: My dear in this moment of moments every man in this room wishes he were I, and every man wants me to fail at getting your number. Before you tell me you have a man or that you are not interested in going out on a date tonight, allow

me to save Face, let me hand you my card. And I'll be on my way!

Heather: You may hand me your card kind sir, I have question for you?

Johnny: ask away, I'll have answer for you!

Heather: what make you think I was going to tell you I have a man, or that I would not be interested in you meeting me tonight at Claim Jumpers??

Johnny: I just assume that a woman with so much beauty, so much class, that you would have a man.

Heather: Johnny I hope you know what they say about assuming?

Johnny: (Laughing) yes I know! Don't forget to call me, (handing the card over).

Heather: I like your swagger Johnny, Johnny Frost, that's a nice name as well!

Beauty in the eyes of the beholder,
Allow me to tell you what I see,

*Who's Heather, she's love on a feather, very confident,
Easy to talk too, highly intelligent,
Not easily embarrassed, she speak her mind,
To hear her voice is a pleasure, when I get to know her better.
Her love I know I would treasure...*

Who's Heather in time I would get to know her better! Too bad our love ended bitter! I should have known better!

*These stories about Heather and our love affairs, in the end it wouldn't be any of the Heathers, When passion came into my life, Heather was leaving, Passion offered something with a lot more depth something love on a feather didn't seem to have.. She was more than a body, she was substance, we actually talked and not just had sex and spent money all day long, she took me out to eat, not the other way around. Passion became my friend, not just my sex partner.
And I found myself, in my Deeper Thoughts,*

Will you sing for me again?

Will you let me win at Pool again?
Will you have a drink for me again?
Will you lie across my bed and just let me hold you again?
I promise I'll be a gentleman again
I told you'll know when it's about you…
Well I see you like the thought
Well let's reap it
Just let me hold you
Just so you know
You can be held
Let me give you a moment of love
Let me be the one
To give you all this
Don't pass it up,
"Oh wow"
I wanna make the house call tonight,
Bring you to my spot, tonight,
Just make the call,
Let me be the one to show you,
We only have one life,
Let's take a chance for once in life
Not asking for you to be my wife
Well only for tonight
Leered see what happens with us tonight

*Let's let take a chance
For romance,
Making reasons for your body to slow dance tonight
Our own private club at my house tonight
Baby don't leave me alone tonight,*

Give me a second cuzz here it come,

let me get off that other bullshit,
Let me do me,
Can't let what others think of me change my creativity,,,
Let me speak with what I know good within myself,
I ain't Mr. West
I Know the Lords walks me doe,
Let my actions speak louder than my words could ever be,
Let nothing change what inspires,,,,
Really I'm living,
And if you got time to watch me live,
then talk shit about me,
Just lets me know I must be doing something interesting,
I can't let those not on my level, interrupt my flow
,But please do continue to speak upon me,
Like the Five Hearts Mentor said,
" learn to use everything,"
So I'ma write everything that comes my way,,,,,,
And don't give a damn what anybody gotta say,,
maybe I'll write something someday,
That'll make all my haters just fade away,,,

Give me a second cuzz here it comes,
Don't need to justify someone else's lies,
If you can't see the truth in my eyes,
Then you ain't looking
I'm here like an open book,
Just take a look when you open your Facebook,
I'll be the first to say I ain't perfect,,,
I'm writing this to music,
So most that don't know how to flow
Gonna miss-understand this,,
I would give you a clue to who's
but that would good for some You's,
Yeah I'ma change my mood,
Cuzz really I'm a good dude,,,
And I really,, I do love some of you...
Just wanna say thanks to all those that I spoke with About what's going,
thanks for not questioning on Facebook about things, cuzz y'all know I would a just answered the questions and not cared who read what I was talking about,,,, and thanks for not pushing the like on this post, cuzz really that's a dead giveaway,,, I still got haters and spies on this page,, lmao.....
Just wanna say thanks again,
Thanks for giving me a second,

Journey of life

If you're on the road to success trust me you're going to lose some friends.

Not everyone you started out with is going to be there when you reach your goals, don't let that deter you, keep going, keep striving, and push yourself to the next level. Let the people that are standing with you push you to the next level and reach back to pull them up with you as well.

I know this all too well, I've lost so many good friend in my life in the last five years, and I've gains so many more as well. I call it season and reasons,

people come into your life for a season there's a good reason for them to be there, at first you may not understand, in time you'll see why, and it's either to give you some good advice or give you a teaching lesson.

Once the reason is complete the season is done, and someone else will take their place... Some seasons never end these people that stay in your life are there for the complete journey of life and that's the reason they've been placed in your life.

I became a life poet
I was writing for the sake of love, family love, relationship love......
Here some great love
She goes back and watches her movie, for about ten more minutes. Then it's back to the questions till dinner time, and one more question right before bedtime,
Love is what love does, her love has endless questions, and I so enjoy them

"Then the next sudden thoughts of life hits,"
Too many of my friends have lost love ones, and silently tears falls reading each ones post in this social media world. There's only so much any of us can do, pray send condolences, And sometimes, that doesn't seem enough.
Suddenly life finds it way, and we move on.
They say there's a thin line between love and hate, there's an even thinner line between reality and Social media....

You take a man like me, a person that expresses his emotion freely, then add into that, building friendship with people across the world, in chatrooms with people I tend to talk with about personal matters, things that really matters in my real life. Cuss it's just me in the room with my computer, it's an illusion. Only to go bed then wake up every morning start chatting to the same person, I'm building bonds with that person. Lost is lost when it comes to friendship. So it hurt to find out I lost a friend to death… even if I did just meet that person on social media….
The little things that will have me in my thoughts,
The little things that inspire my passion,
The little things that create so much emotions,
These poems been coming for some time, to many of my friends have lost love ones this year, and silently tears fell from my eyes reading each ones post, I wouldn't be left out of losing friends to death as well.
The mood would change one more time, and the thoughts would become intense once again, funny how death inspires creative thoughts. I started losing friends while writing the thoughts of saint and sinner, friends

from a far and close wanted me to write openly, I couldn't do it,. Wrote the poems and never posted.
There's only so much any of us can do, pray send condolences, and sometimes, that doesn't seem enough.
And then like a sudden thought,
The truth of the matter I Heather and I were great in bed, bad as friends and good as lovers, as long as she needed me, I needed her, when she no longer need me. I no longer wanted her!
What happen in this next little story kind of shocking?
Cheating with a married woman, At some point you would think I would have a handle on situations like this, yet the dog in me never seems to learn, I went over to this woman house, made love to her, as if she were my woman, in my heart I was saying this is so wrong, in my mind I didn't care. Making love to a married woman was a thrill in itself. Even bigger thrill keeping the secret from my own woman. I was in love with my woman, I just wanted a little excitement!

And like sudden thoughts everything changes
Random flirting, ego out of control, dropping lines, just to get a hello!
It always seems I'm writing for someone, sometimes what inspires my write could be a song that I wanted to rewrite into my own words, the beat had me going.
Once I post it on line people tend to take it for whatever they want, sometimes poems I write may mean nothing to me, but everything for someone else, so I just take as that's the reason I write it in the first place.
These sudden thoughts, many people have them, the only difference is that I tend to write mine down more than others, writing for myself is a healing tool.
If I inspire others to do the same, that's a side effect, I truly believe that writing is contagious... I've watched others read someone's work and a day or two later they'll write some the most inspiring poetry... Like sudden thoughts.

Like a Sudden Thought on to the next,
I keep going through these relationships, still wanting to

get married. Every word in these poems is real, still Maybe one day I'll find that one that will say yes, Lady love please say yes,,,,,
With all that's going on in the world today, really, Life too short to be looking for the prefect one, I got to
find that one that's going to put up with my mess... Sudden thoughts of giving up on relationship, yeah it happens, something or someone always comes alone to change my mind.
I keep my faith as much as anyone else.
There's are times you've read about me going smooth off in this book, yeah even I get on one, Can't always be emotional about the women in my life,
Sometimes we all have to take a minute to look at the lager of life

Sudden thoughts about my childhood and writing, When I started writing as a child I was doing it for fun, not for show, but I loved the thought of making a record about life, just writing every little moment, as a child I told myself one day I'll write something that'll shock the

world, big dreams like any kid, as I got older the need to write kind of faded away, you know what happened. Girls, and like any teenage boy. My writing started coming out in things I would say to girls, girls were like are you a poet? My reply, baby I'm whatever you want me to be for the night, most times the girls would just laugh and smile,
As time goes on so does life move on,
Children, job, street hustling, cheating you know, life.
Poetry started to come back in the strangest way, I would write on everything, I do mean everything, just to get my thoughts out. My Children's mother would get upset to come home seeing I redecorated the house with poetry on the closet doors, and walls. She would say things like are you a mad man? So for my 26 birthday she got me a note pad, write on this she said, to this day I think it's funny.
As time goes on so does life move on,
You know I hide nothing from anyone, yes I've been to prison,
I'll be the first to say I'm not perfect to anyone standard, not even my own, I make mistakes. But I've always

taken it as it's what you learn from the mistakes, that makes the person not the mistake itself. I could be wrong. Prison time, especially Federal time will give you a lot to think about when it comes to mistakes, I used that time as wisely as I could, I wrote and read everything I could, my routine, 200 push-up,
an hour of reading religion. Then to the chow hall for work, taking my pen and pad, So when chow was done, I clean up with the rest of the fella, then CO would let everyone go back to the yard, I would stay in the chow hall, rather than hanging out, I needed write, and do more push-up, next hour movement I would go to the weight yard, lift with the Watts set, cuzz No one from San Bernardino was on fed time but Johnny Frost at Terminal Island.

Even Sudden thoughts can turn into Finale poems

Let me take my time with this one, I need the thoughts to flow like water,
Need that thought of passions to be the melody,
Desires of the heart to be limitless,
Prayers to be heard from the earth to the heavens,
Dreams turning into reality,
I'm telling you all that I need, I'm you telling I'm willing to change my world
Can I write for you, became my theme to see who was actually reading before I posted a poem on social media, most times I already had the poem wrote,
I would just wait to see who would respond. Can I write for you?
Sudden Prayers,
Just show me a path,
Never one for depression
even though life can be stressing,

Do I go left, or do I go right
I believe I'm one of your living blessing
I'm not an activist, yet my mind and pen stays active,
I'm no longer just another person posting poems
I'm a poet, I'm a son, big brother, big truck driver, lover like no other,
I'm an Author now, and with saying that come with responsibility,,
People truly do look at you different, and it's not always a good thing
Learning lessons about this blessing,
Sudden self-Check
There will be some that will love and support,
My responsibility for myself, is to stay in control of my ego,
Staying humble is truly a must, well how do I do that,
I stay with my family and friends, and only reach out, to those who reach out!
Still knowing growth is that great change that has to come within self.
I'm not an activist, yet my mind and pen stays active

Suddenly longing
I need you to know that these words are for you,
I know it's been sometime since I got a chance to write for you,
I know it's been crazy these last few nights,
I know haven't been affectionate as a man should be,
I know you've been really patience with me,
(whispers) I know I know I know,
You have to know, these words are for you,
You have to know these spill of expression come from my heart and soul.
You have to know, you're the only woman in my heart and soul
you have to know, that I'm loving you forever more,
you have to know, that you are the one for me,
(whispers) you have to know, you have to know, you have to know

Sudden Confessions
I stopped writing for a while till then this came out
I've been reading more poets as of late, trying to gain my love of poetry again, I went to few unnamed poets, I mean their big name poets, I just won't mention names, cuzz really they may be ashamed to even know my name, Kind of sad, where the support in the poetry game,
Sudden Thoughts of life
These stories are mine and taken outta the journey of my life

They say it's not very much beauty in pain, Sit down with me for a while,
 Listen to my story, its written pain into eloquence....
When I'm done all that I request is that you "like".

Still these are the thoughts of a Saint and Sinner, Still speaking to the next

Please Visit our websites for more great poetry and book, as well as our events in the Local area of the Inland Empire...

{ HYPERLINK "file:///J:\\Sudden%20work\\PoeticKnightsinc.com" }

www.ingramcontent.com/pod-product-compliance
Lightning Source LLC
Chambersburg PA
CBHW020857180526
45163CB00007B/2539